Stars & stripes

The
Star-Spangled Banner is an
art form in itself
and an endearing part of
American history.

STARS&STRIPES

Ninety-six top
designers and graphic
artists offer their personal
interpretations of
Old Glory.

Compiled and Designed by
Kit Hinrichs

Edited by
Delphine Hirasuna

Chronicle Books · San Francisco

Design:
Kit Hinrichs, Pentagram

Editor:
Delphine Hirasuna

Photography:
Michele Clement, Barry Robinson,
Terry Heffernan

Project Coordinator:
Amy Hoffman

Production Manager:
Tanya Stringham

Chronicle
Production Director:
David Barich

Chronicle Staff:
Fearn Cutler, Bill LeBlond

Printed in Japan
by Dai Nippon.

Chronicle Books
One Hallidie Plaza
San Francisco, CA 94102

While some historians credit Francis Hopkins as the Stars and Stripes principal designer and Betsy Ross as its artist, George Washington may actually have been this country's first design director. Legend has it that he virtually "roughed it out" in a verbal presentation before the Continental Congress saying, "We take the stars from heaven, the red from our mother country, separating it by white stripes, thus showing that we have separated from her, and the white stripes shall go down to posterity representing liberty." In contrast to the ornate banners and pennants of the European monarchies, the Stars and Stripes was a dramatic and decidedly modern national symbol, ultimately becoming the archetype for the flags of other republics. It is also an enduring symbol: repeated but never clichéd, satirized but never trivialized, altered but never destroyed. Since its adoption on June 14, 1777, Americans have reinterpreted the flag in countless ways for political, commercial, and artistic uses. While regulations were devised in 1934 to govern its formal application, these do not impinge on the flag as the basis for art. The ninety-six interpretations shown here prove that the Stars and Stripes is versatile and unmistakable regardless of configuration. This book is the result of an exhibition organized by the San Francisco chapter of the American Institute of Graphic Arts to coincide with the one hundredth anniversary of the Statue of Liberty. The illustrators and graphic designers involved were not asked to redesign but, rather, to interpret the flag in any way and with any medium. The results are variously comic, ironic, elegant, and fanciful. It is quite appropriate that these artists, who are accustomed to manipulating metaphor and symbol, were asked to interpret one of the world's most charged symbols. Given the outcome, I'm sure that even design director Washington would be proud.

America's Founding
Fathers ruled out numerous designs before the
Continental Congress, on June 14, 1777,
"resolved that the Flag of the united states be 13
stripes alternate red and white,
that the Union be 13 stars white in a blue field
representing a new constellation."
Perhaps more than any other national flag, the American
emblem has evolved over many years.

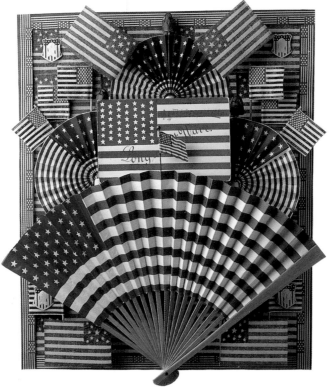

The original design guidelines
were sufficiently broad to allow for liberal
interpretation. That meant that Americans felt free to
rearrange the field of stars as they liked and to
display the flag proudly in a plethora of unconventional
guises. The range of expression, which ran from
fine art to work of such poor taste that it bordered on
desecration, aroused demand for flag codes. In
1912, the federal government approved the first of a
series of detailed design standards. In 1934,
lawmakers finally specified official color shades. More
than a century without guidelines, however,
produced a wealth of ephemeral flag objects, which
are a special part of the American heritage.

LOG CABIN QUILT
Nevada, 1910

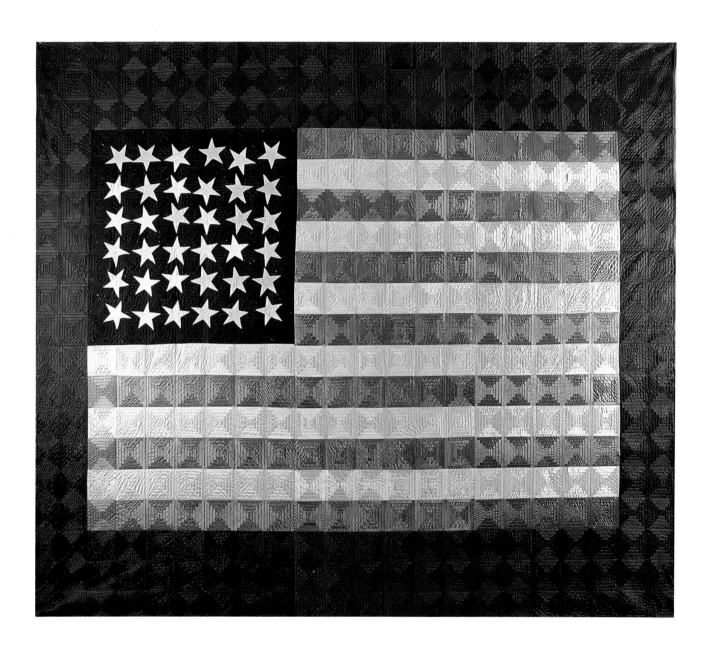

A ten-woman
sewing bee in Nevada created this silk Log Cabin
pattern quilt in 1910. The 88″ × 104″
flag later hung in the office of the police chief of
San Francisco.

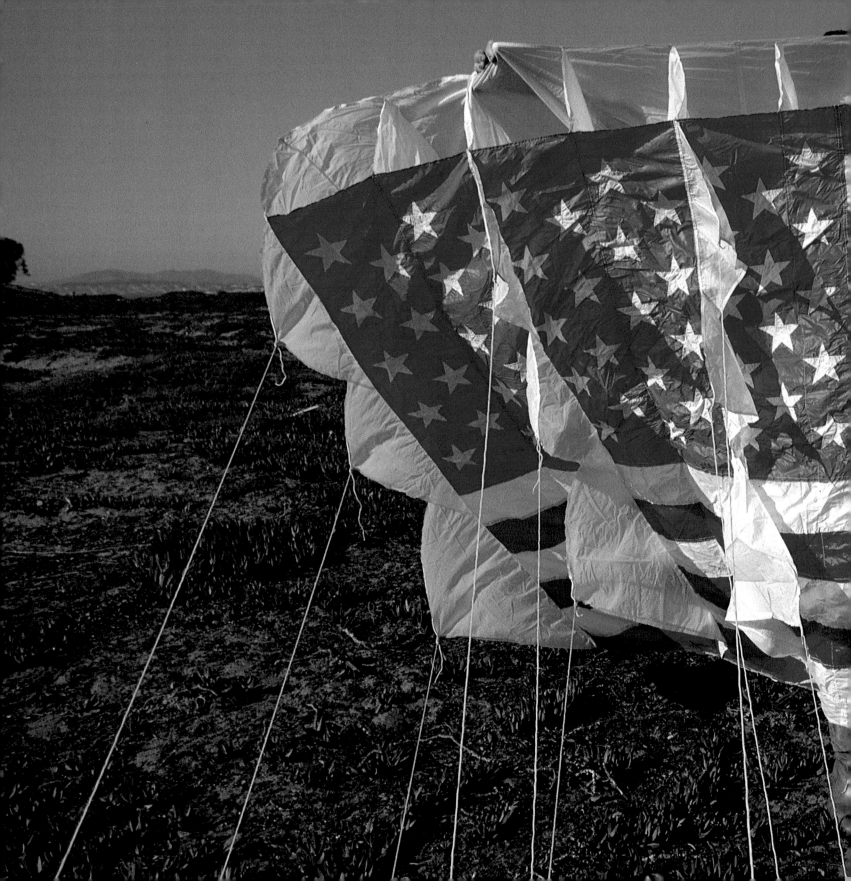

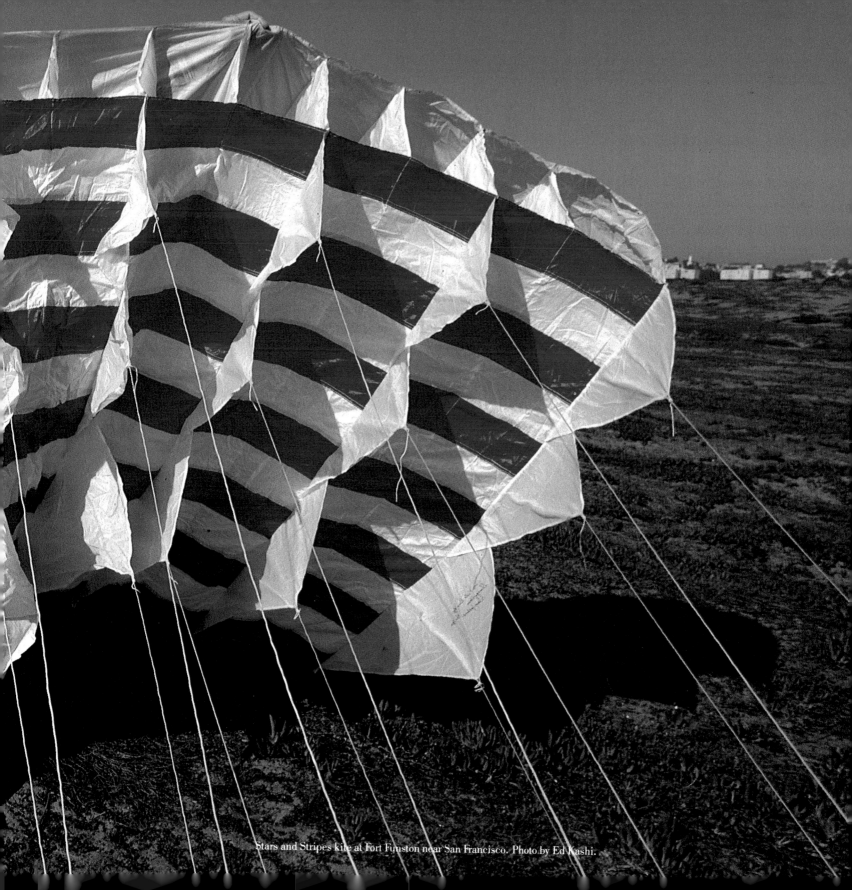

Stars and Stripes kite at Fort Funston near San Francisco. Photo by Ed Kashi.

FLAG MEMORABILIA

Historic Interpretations
From the 1860s to 1970s

Flag Fan, circa 1976

Wooden Farm Gate, circa 1870

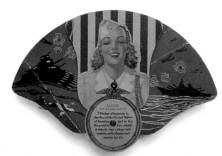

Patriotic Fan, circa 1942

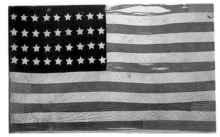

Navaho Weaving, circa 1973

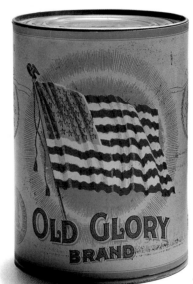

Canned Asparagus Label, circa 1930

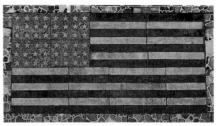

Masonry Wall, circa 1950

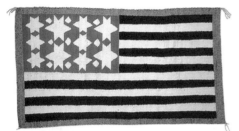

Woolen Flag, circa 1865

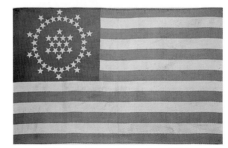

Whipple Peace Flag, circa 1914

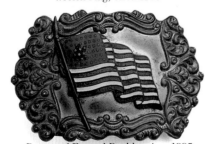

Brass and Enamel Buckle, circa 1895

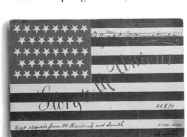

Postcard, circa 1899

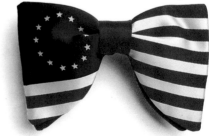

Bicentennial Bow Tie, circa 1976

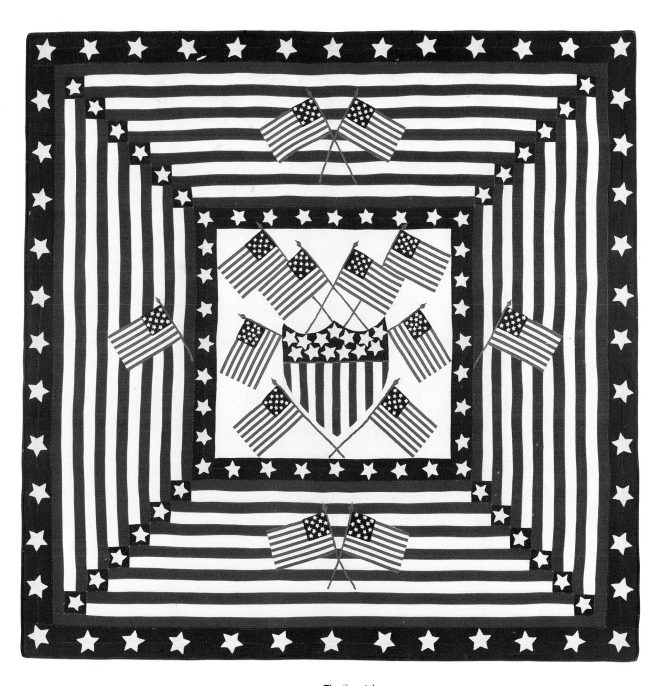

The Spanish-
American War of 1898 was the first war fought by the
reunited northern and southern states.
American patriotic spirit was strong. This pieced and
appliquéd cotton quilt was made by Mary Baxter
of Kearny, New Jersey, in 1898.

On the Fourth
of July, 1986, the San Francisco chapter
of the American Institute of Graphic
Arts celebrated the reopening—and one
hundredth anniversary—of the
Statue of Liberty with an exhibition
of American flag art. The AIGA chapter
invited illustrators and graphic
designers to present their interpretations
of the Stars and Stripes in any art medium,
within a twelve-by-eighteen-inch
format. Their creations are presented
on the following pages.

CHRIS HILL
Houston, Texas
Pencil assemblage

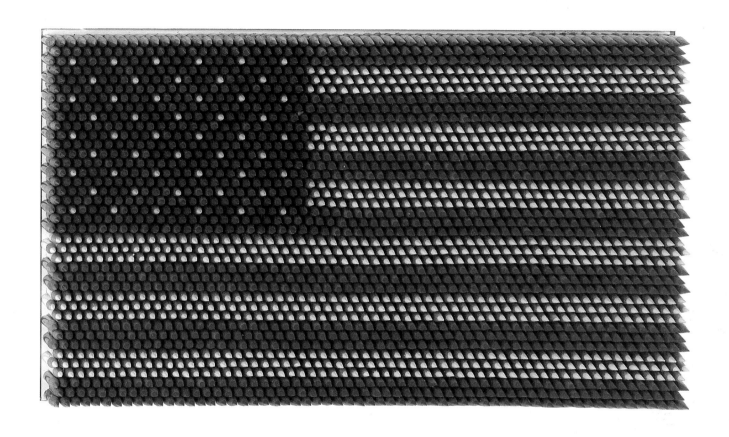

Since 1981,
award-winning Chris Hill has been creative director
of The Hill Group, a marketing design firm
that handles projects ranging from package design
and advertising campaigns to annual reports
and corporate identity. Hill's work is represented
in the Ellis Island Commemorative
Museum and the permanent collection of the
Library of Congress.

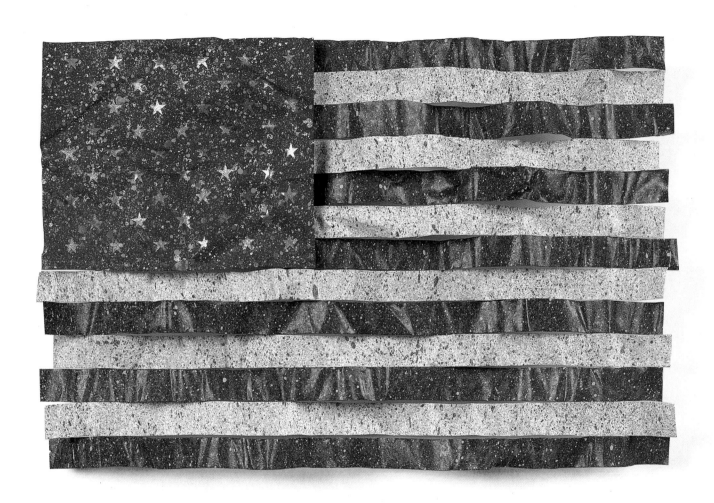

Prior to forming
Sibley/Peteet Design in 1982 with partner Rex Peteet,
Don Sibley worked for several advertising and
design firms in Dallas, including The Richards Group
and Dennard Creative. Sibley's work is included
in the permanent collection of the Library of Congress.
An award-winning designer, he lectures at national
seminars and served as cochairman of the
first AIGA Texas Design Retrospective Exhibition.

MICHAEL MANWARING
San Francisco, California
Serigraph with Gold Leaf

Award-winning
designer Michael Manwaring established The Office of
Michael Manwaring in 1976. It handles a
number of national and international projects in archi-
tectural and environmental graphics and
exhibition design. In 1982, the San Francisco chapter
of the American Institute of Architects chose
Manwaring to design its centennial exhibition at the
San Francisco Museum of Modern Art.
Manwaring has taught and lectured at universities
in the U.S. and Chile.

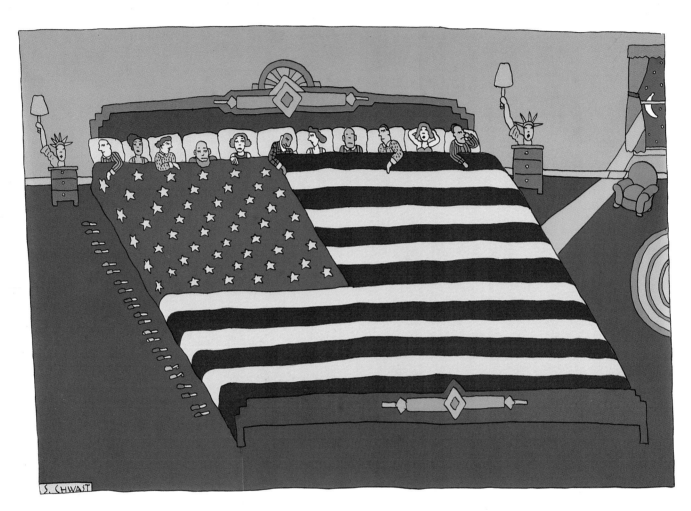

A founder of
Push Pin Studio, Seymour Chwast is now the director of
The Pushpin Group. His designs and
illustrations have appeared in virtually every medium,
including more than a dozen children's
books, and have been exhibited internationally in gal-
leries and museums. In 1986, a book
of his work entitled *The Left Handed Designer* was
published, and his thirty-year career
was honored by the Cooper Union with a retrospective
exhibition. Chwast was elected to the
New York Art Directors Club Hall of Fame and received
the AIGA gold medal in 1986.

A graduate of
the University of Arkansas, Woody Pirtle is a principal
of Jonson Pirtle Pedersen Alcorn Metzdorf &
Hess. Pirtle's award-winning designs are included in
the permanent collections of the Library of
Congress, the Cooper-Hewitt Museum, and the Museum
of Modern Art. Other honors include several
New York Art Directors Club gold medals, and being
named as the Individual and Corporate Com-
municator of the Year by the Art Directors Club of
Houston. Pirtle is a member of the Alliance
Graphique Internationale and has served on the
national board of the AIGA.

JACK SUMMERFORD
Dallas, Texas
Gouache on board

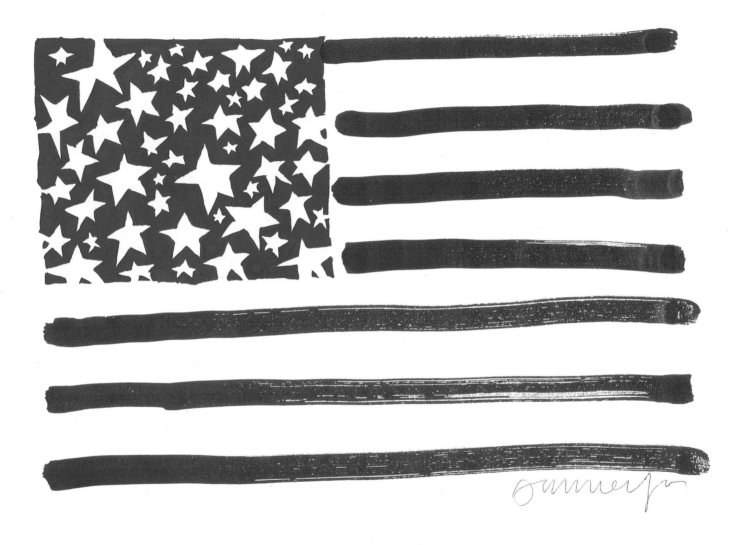

After thirteen years
with other graphic design firms, including eight with
Stan Richards, Jack Summerford founded
Summerford Design in 1978. Summerford's work has
garnered top design awards and has been
featured in several prestigious design publications.
Based in Dallas, Summerford lectures before
design groups and served on the founding board of the
Texas chapter of the AIGA.

SANDRA McHENRY
San Francisco, California
Polaroid assemblage

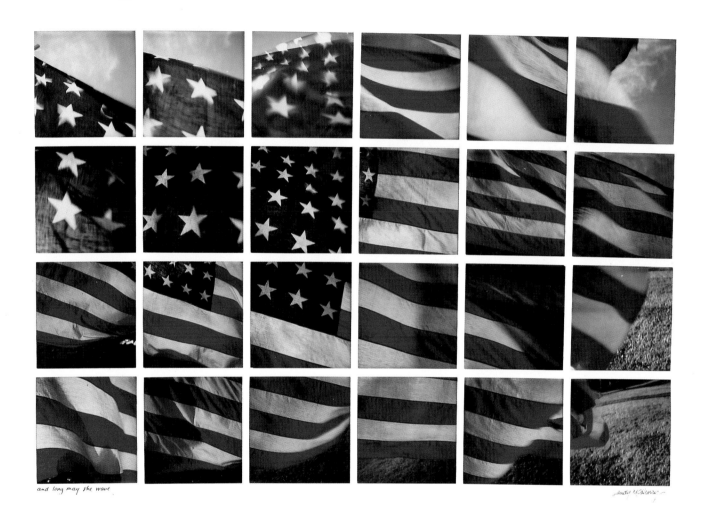

and long may she wave

Born and
educated in Montana, Sandra McHenry is now a graphic
designer in the San Francisco office of Pentagram.
Her interest in graphic design developed after a summer
studying industrial design in Florence,
Italy. She continued her studies at California State
University, Chico. McHenry previously
worked as a designer with Lawrence Bender & Asso-
ciates in Palo Alto, California, and Ramirez
and Woods in New York.

DOUG AKAGI
San Francisco, California
Sandblasted Andes granite

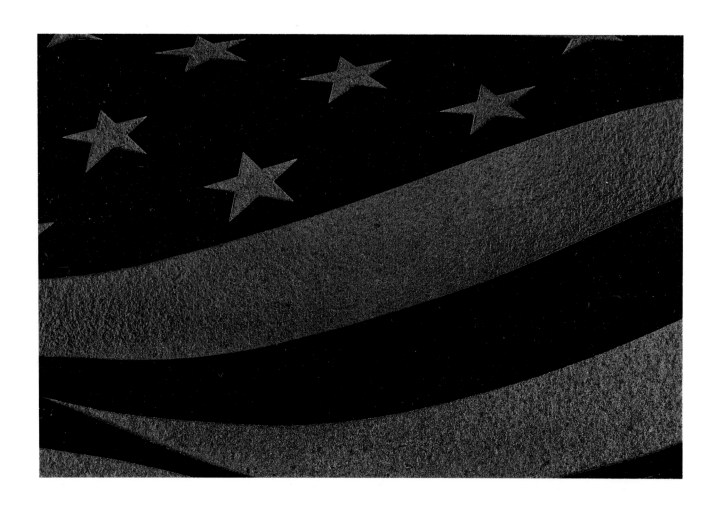

Born and raised
in the United States, Doug Akagi began his graphic
design training in Tokyo. His San Francisco-based
firm, Akagi Design, produces print and
environmental graphics for a broad range of national
clients. His work has been published both
here and abroad and has been recognized with numer-
ous awards for excellence. Akagi teaches
at the California College of Arts and Crafts.

TIM LEWIS/ALAIN J. BRIERE
New York, New York
Illustration board construction

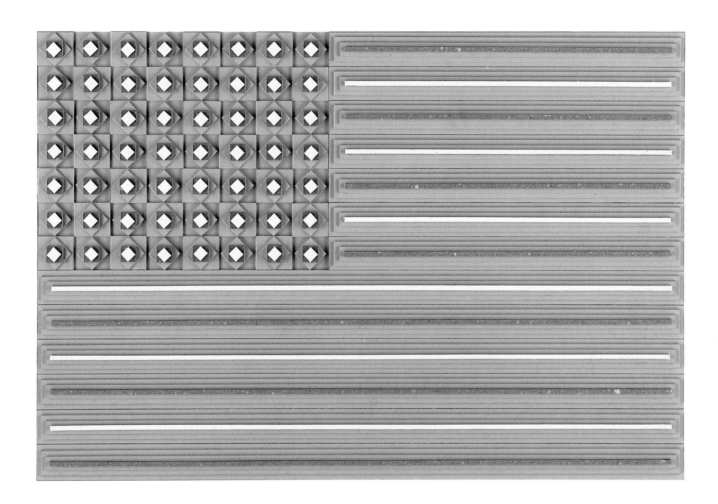

Previously an
illustrator with Push Pin Studio, Tim Lewis now works
as a free-lance editorial illustrator, producing
award-winning art for magazines and newspapers, as
well as for corporate communications and
advertising. **A**lain J. Brière is a French-born graphic
designer from Montreal. After graduating from
The Portfolio Center in Atlanta, Brière worked for Lou
Dorfsman at CBS Inc. and as a free-lancer
for several corporate and editorial design firms. He
currently works at The Graphic Expression Inc.,
specializing in corporate annual reports.

CARL SELTZER
Newport Beach, California
Popcorn and paper collage

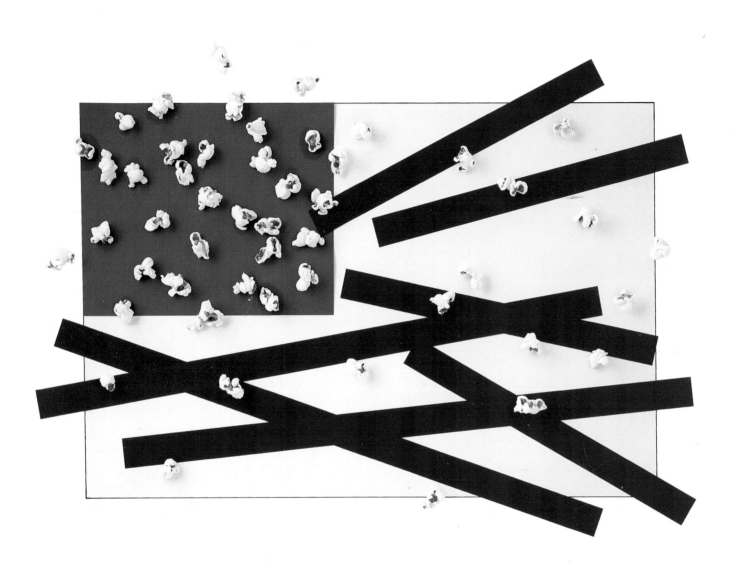

Carl Seltzer is the
principal of Carl Seltzer Design Office, which
specializes in corporate communications. Seltzer's
work has appeared in major design publications
and shows, winning both gold and silver medals from
the New York Art Directors Club, a Belding
Cup, and several best of show awards. He has taught
at the Art Center College of Design
and California State University, Northridge.

RUBEN DE ANDA
San Diego, California
Watercolor collage on paper

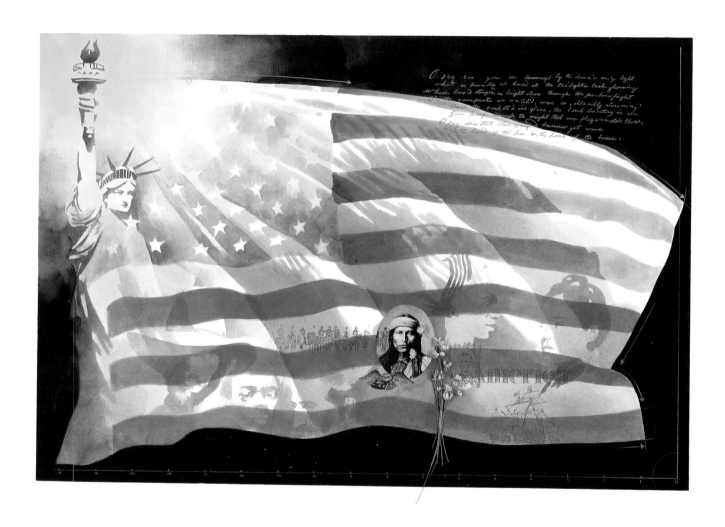

After graduating
with a bachelor of arts degree in illustration from the
Art Center College of Design, Ruben DeAnda
worked as a free-lance illustrator in New York City, then
as staff illustrator for Dixeno Advertising in
Mexico City. DeAnda is now based in San Diego, where
he works as a free-lance illustrator and teaches
at San Diego State University.

KIT HINRICHS
San Francisco, California
Paper collage

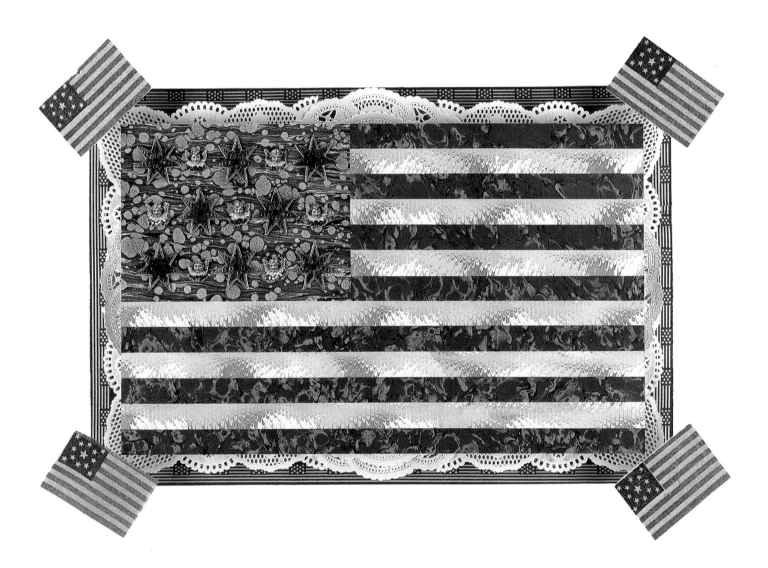

<P>rior to
becoming a partner of Pentagram, Kit Hinrichs was a
principal of Jonson Pedersen Hinrichs & Shakery.
His graphic design for corporate clients has received
hundreds of coveted awards. Hinrichs has
taught at the School of Visual Arts and the Academy
of Art College. He is coauthor of the book
Vegetables. His work is included in the permanent col-
lection of the Museum of Modern Art. Hinrichs
serves as an executive board member of the AIGA.

BRUCE BLACKBURN
New York, New York
Serigraph

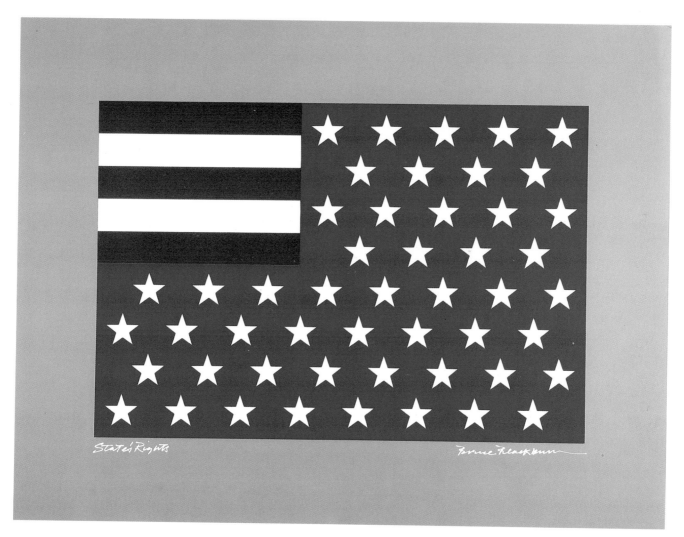

Principal of
Blackburn & Associates, Bruce Blackburn has received
numerous graphic design honors, including
the Presidential Award for Design Excellence bestowed
by President Ronald Reagan. Blackburn is
the current president of the AIGA; author of *Design
Standards Manuals*, published by the National
Endowment for the Arts; a member of the Alliance
Graphique Internationale; and a Carnegie pro-
fessor of graphic design at the Cooper Union. He also
lectures at universities around the country.

JAMES CROSS
Los Angeles, California
Paint on cloth

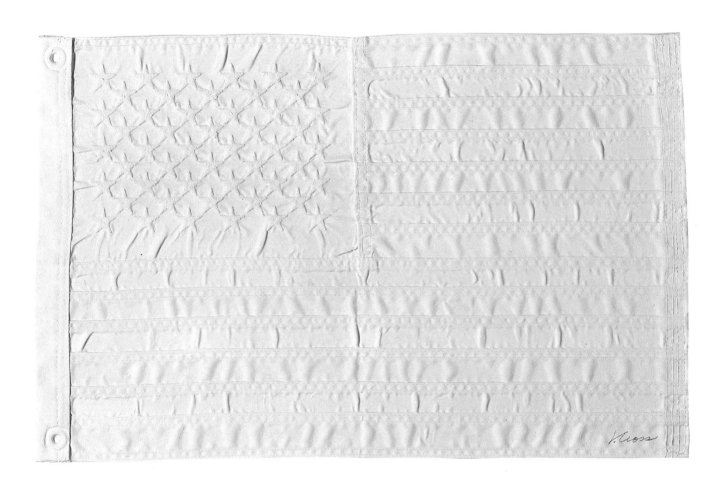

Principal of
Cross Associates, with offices in Los Angeles and
San Francisco, James Cross is an international award-
winning graphic designer, photographer, and print-
maker. He is an adjunct professor at Arizona State
University and a member of the advisory boards
of the Art Center College of Design and the Art Directors
Club of Los Angeles. He sits on the executive
committee of the Alliance Graphique Internationale and
serves as president of the Société Joie du Vin.

LISSA ROVETCH
San Francisco, California
Mixed media construction

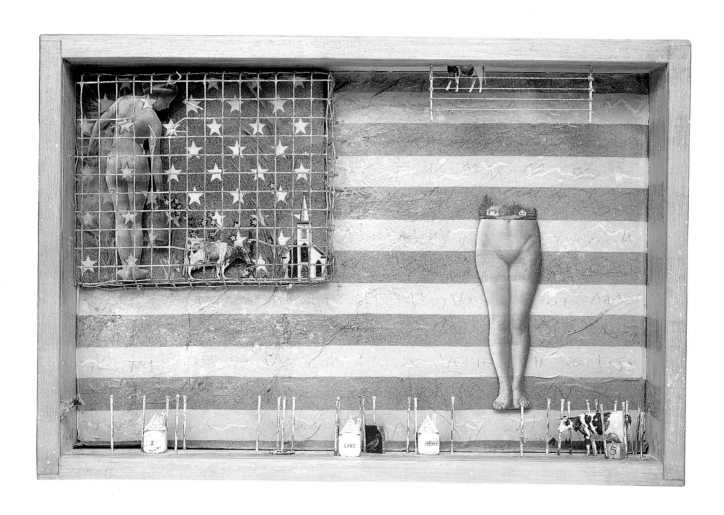

Lissa Rovetch
studied and worked in Paris and New York.
She received a bachelor of fine arts
degree from Parsons School of Design, before
moving to San Francisco. Her recent
free-lance assignments bring a fine-arts perspec-
tive to commercial projects, which
have ranged from artwork for airline interiors
to magazine illustrations.

SUSIE REED
San Francisco, California
Color Xerox collage

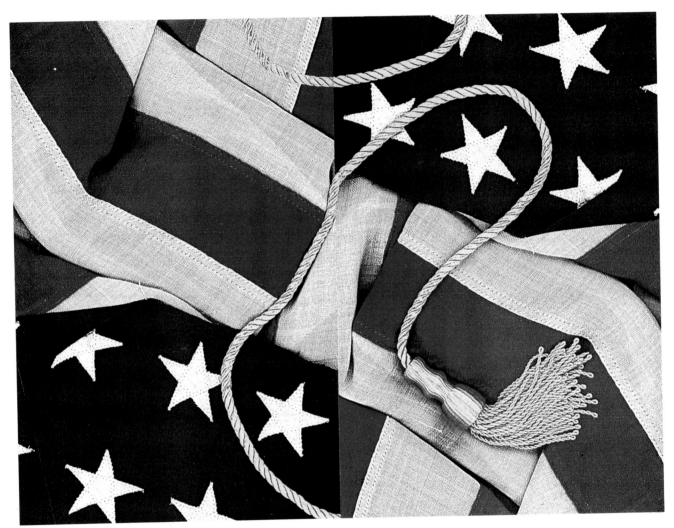

Artist Susie Reed
has developed a unique technique of making prints from
actual three-dimensional objects placed
directly on the glass of a color copier machine. Reed
has taught this technique at the San Francisco
Art Institute and the California College of Arts and
Crafts. In addition to producing commercial
projects, she has had her work exhibited at several
fine arts museums around the country,
including the de Young Museum, the Cooper-
Hewitt Museum, and the George Eastman House.

MERVYN KURLANSKY
London, England
Plexiglas construction

A founding partner
of Pentagram, an international design firm, Mervyn
Kurlansky previously headed the graphic
design department at Knoll International's Planning
Unit before joining Crosby/Fletcher/Forbes
in 1969. Among his many accolades are silver awards
from the Designers and Art Directors Association
of London. He is a fellow of the Chartered
Society of Designers and the Society of Typographic
Designers and a member of the Alliance
Graphique Internationale.

MARSHALL ARISMAN
New York, New York
Collage of paintings

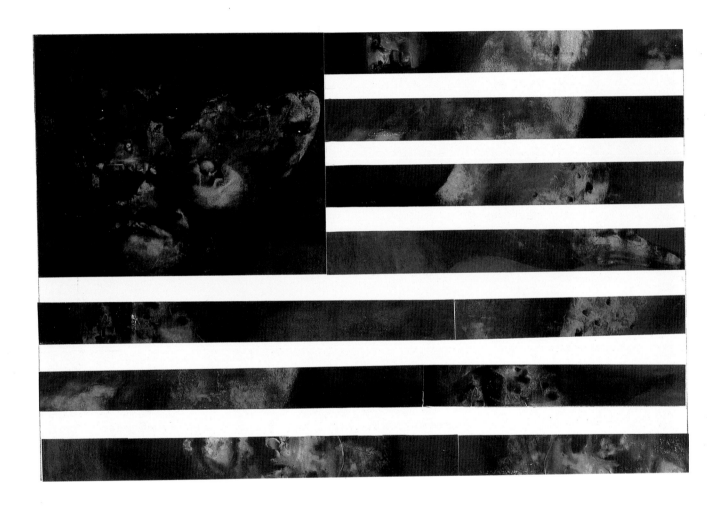

Marshall Arisman's
editorial drawings and illustrations have appeared in
the nation's leading publications, among them
the *New York Times*, *Esquire*, and *Rolling Stone*. His
work has appeared in one-man shows in
New York and Poland, and has been featured in such
books as *Frozen Images*, *Art of the Times*,
and *Images of Labor*. In 1979, *Playboy* magazine named
Arisman Illustrator of the Year. He has re-
ceived numerous other awards, including the New York
Art Directors Club gold medal.

STEFF GEISSBUHLER
New York, New York
I. N. T. transfer on paper

Any person who, within the District of Columbia, in any manner, for exhibition or display, shall place or cause to be placed any word, figure, mark, picture, design, drawing, or any advertisement of any nature upon

any flag, standard, colors, or ensign of the United States of America; or shall expose or cause to be exposed to public view any such flag, standard, colors, or ensign upon which shall have been printed, painted, or otherwise placed,

or to which shall be attached, appended, affixed, or annexed any word, figure, mark, picture, design, or drawing, or any advertisement of any nature; or shall manufacture, sell, expose for sale, or to public view, or

give away or have in possession for sale, or to be given away or for use for any purpose, any article or substance being an article of merchandise, or a receptacle for merchandise or article or thing for carrying or transporting

merchandise, upon which shall have been printed, painted, attached, or otherwise placed a representation of any such flag, standard, colors, or ensign, to advertise, call attention to, decorate, **mark**, or distinguish the article or substance on which so placed shall be deemed guilty of a misdemeanor and shall be punished by a fine not exceeding $100 or by imprisonment for not more than thirty days,

or both, in the discretion of the court. The words "flag, standard, colors, or ensign", as used herein, shall include any flag, standard, colors, ensign, or any picture or representation of either, or of any part or parts of either, made of any substance or represented on any substance, of any size evidently purporting to be either of said flag, standard, colors, or ensign of the United States of America or

a picture or a representation of either, upon which shall be shown the colors, the stars and the stripes, in any number of either thereof, or of any part or parts of either, by which the average person seeing the same without deliberation may believe the same to represent the flag, colors, standard, or ensign of the United States of America. Act of July 5, 1968, *U.S. Statutes at Large.*

Born and educated in Switzerland, Steff Geissbuhler is a partner of Chermayeff & Geismar Associates. Geissbuhler has been in charge of graphics for such major projects as the Smithsonian Institution's bicentennial exhibit and has designed identity systems for NBC, the Alvin Ailey American Dance Theatre, and the IBM headquarters in New York. Geissbuhler's award-winning works have twice earned him the First Swiss National Prize for applied arts. He is a member of the Alliance Graphique Internationale.

LINDA HINRICHS
San Francisco, California
Glass beads and metal tubing

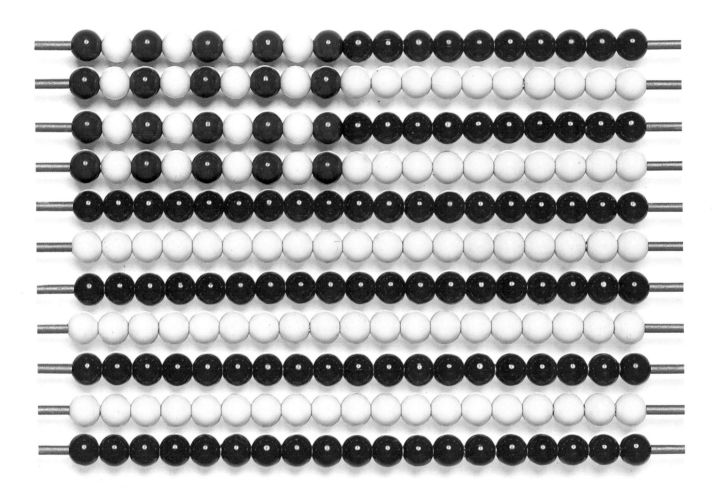

Linda Hinrichs
graduated from the Art Center College of Design and
worked in advertising and editorial graphics
in New York. She was a principal in the design firm of
Jonson Pedersen Hinrichs & Shakery before
becoming a partner in Pentagram. Hinrichs is the
recipient of numerous awards and her work
has been featured in leading design publications.
She recently served as the president
of the San Francisco chapter of the AIGA.

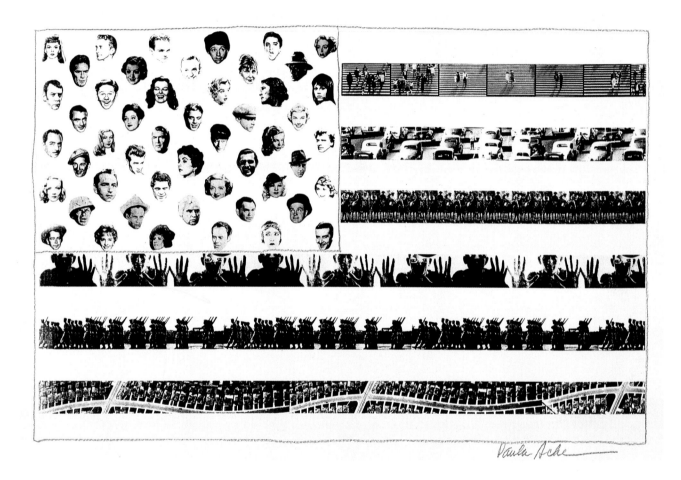

Formerly an art
director for CBS Records, Paula Scher designed two
new magazines for Time Inc. and is the
author-designer of two books. She is also a founding
partner of Koppel & Scher. Scher's designs
are in the collections of the Museum of Modern Art, the
Library of Congress, the Georges Pompideau
Center, and the Maryland Institute of Art. In 1983,
the Society of Typographic Arts honored
her with a one-woman show. Scher has received gold
medals from the New York Art Directors Club,
four Grammy nominations for album covers, and several
other design awards.

MICHAEL VANDERBYL
San Francisco, California
Cromatec on paper

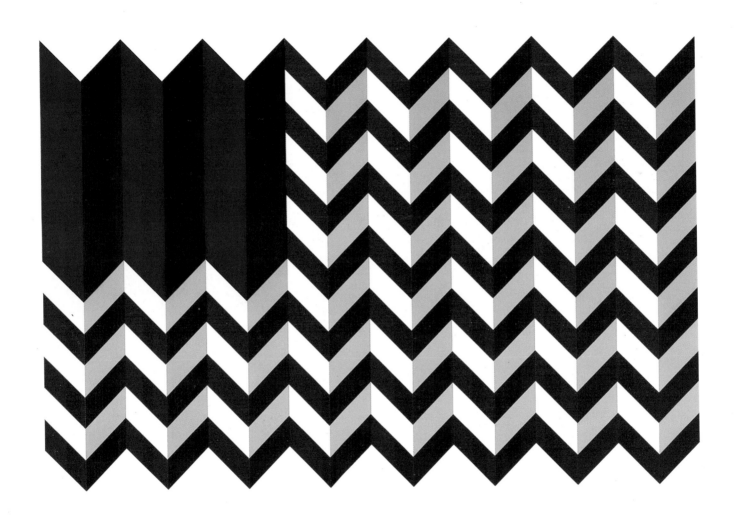

Michael Vanderbyl's
Vanderbyl Design serves a wide range of corporate
clients, museums, and institutions.
Vanderbyl is dean of the School of Design at the
California College of Arts and Crafts. His
work is included in the permanent collections of
the Cooper-Hewitt Museum and the Library
of Congress. A frequent recipient of highly respected
design awards, Vanderbyl is a member of
the Alliance Graphique Internationale and was
featured in *Seven Graphic Designers*, edited
by Takenobu Igarashi, among other publications.

DUGALD STERMER
San Francisco, California
Pencil and watercolor on paper

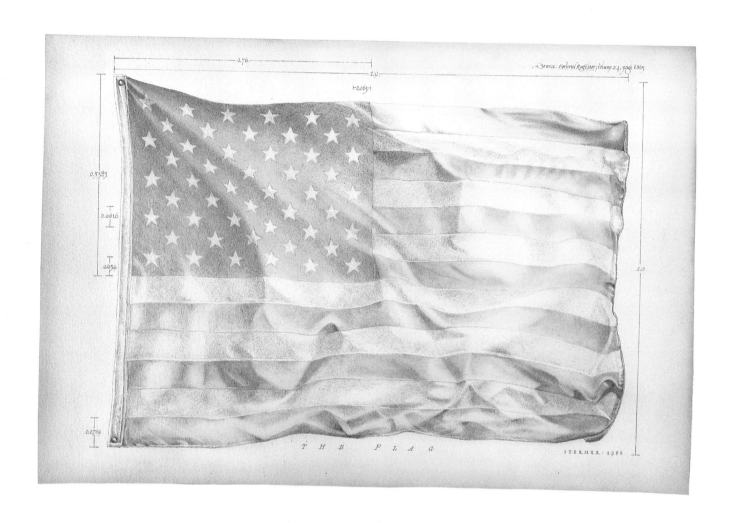

Dugald Stermer is
a designer, illustrator, and writer. He designed the
1984 Olympic Games medal, has created covers
for *Time* magazine, and has produced illustrations for
other major publications and for advertising
and corporate clients. Stermer is associate editor for
Communications Arts magazine. He is the
author of *The Art of Revolution*, *Vanishing Creatures*,
and the upcoming *Vanishing Flora*.
Internationally renowned for his wildlife and botanical
illustrations, Stermer was honored with a one-
man exhibition by the California Academy of Sciences.

JAMES MIHO
West Redding, Connecticut
Collage and type

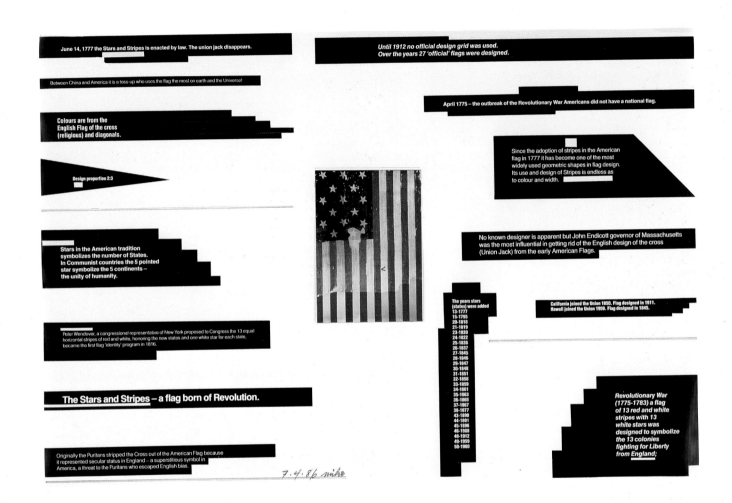

June 14, 1777 the Stars and Stripes is enacted by law. The union jack disappears.

Until 1912 no official design grid was used.
Over the years 27 'official' flags were designed.

Between China and America it is a toss-up who uses the flag the most on earth and the Universe!

April 1775 – the outbreak of the Revolutionary War Americans did not have a national flag.

Colours are from the
English Flag of the cross
(religious) and diagonals.

Since the adoption of stripes in the American
flag in 1777 it has become one of the most
widely used geometric shapes in flag design.
Its use and design of Stripes is endless as
to colour and width.

Design proportion 2:3

No known designer is apparent but John Endicott governor of Massachusetts
was the most influential in getting rid of the English design of the cross
(Union Jack) from the early American Flags.

Stars in the American tradition
symbolizes the number of States.
In Communist countries the 5 pointed
star symbolize the 5 continents –
the unity of humanity.

The years stars
(states) were added
13-1777
15-1795
20-1818
21-1819
23-1820
24-1822
25-1836
26-1837
27-1845
28-1846
29-1847
30-1848
31-1851
32-1858
33-1859
34-1861
35-1863
36-1865
37-1867
38-1877
43-1890
44-1891
45-1896
46-1908
48-1912
49-1959
50-1960

California joined the Union 1850. Flag designed in 1911.
Hawaii joined the Union 1959. Flag designed in 1845.

Peter Wendover, a congressional representative of New York proposed to Congress the 13 equal
horizontal stripes of red and white, honoring the new states and one white star for each state,
became the first flag 'identity' program in 1816.

Revolutionary War
(1775-1783) a flag
of 13 red and white
stripes with 13
white stars was
designed to symbolize
the 13 colonies
fighting for Liberty
from England;

The Stars and Stripes – a flag born of Revolution.

Originally the Puritans stripped the Cross out of the American Flag because
it represented secular status in England – a superstitious symbol in
America, a threat to the Puritans who escaped English bias.

7.4.86 miho

James Miho is the
principal of Miho Design. His work is included in the
permanent collections of the modern art museums
in New York, Sao Paulo, and Helsinki, and has been
exhibited in Tokyo and Rio de Janeiro. Miho
has been a consultant to the Museum of Contemporary
Crafts, the Whitney Museum of American Art,
and the Smithsonian National Air and Space Museum.
In 1980, he won the gold medal for
the best industrial film at the Cannes Film Festival.

JOEL KATZ
Philadelphia, Pennsylvania
Map pins and cloth

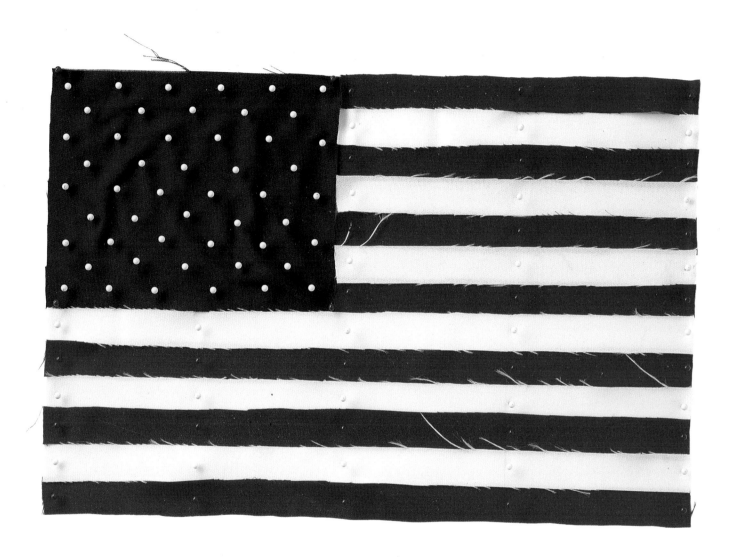

A partner of
Katz Wheeler Design in Philadelphia, Joel Katz
is the author of two books and the
recipient of numerous awards for design. A graduate of
Yale University, Katz has taught at Yale, the
Rhode Island School of Design, and the Philadelphia
College of Art. He is a former director of the
AIGA and his work is in the permanent collection of
the Museum of Modern Art. Katz has partic-
ular interest and expertise in maps, diagrams, and the
visualization of complex data.

HANK OSUNA
San Francisco, California
Acrylic paint on board

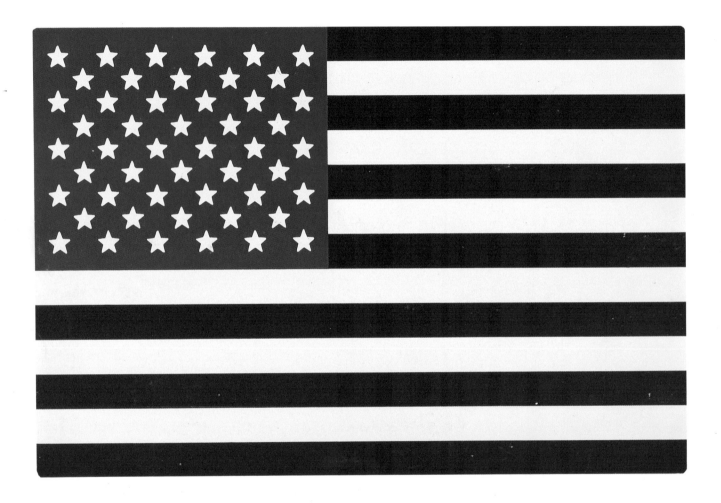

A self-taught
illustrator, Hank Osuna has had his work show-
cased in periodicals and books and has
been recognized with awards from the AIGA, the
New York Art Directors Club, the
Society of Communicating Arts, and the Society
of Illustrators. In 1975, Osuna received
a scholarship from the Academy of Art College.

JOHN VAN DYKE
Seattle, Washington
Type "C" print

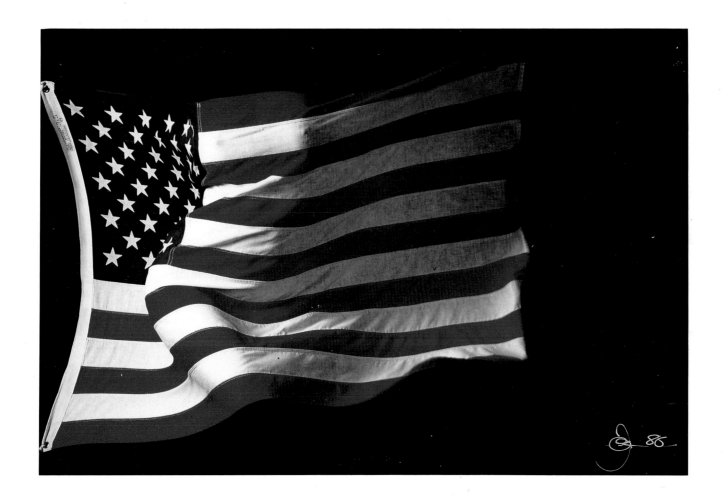

A native of Seattle,
John Van Dyke is principal of the Van Dyke Company,
which designs everything from exhibits and
packaging to corporate publications for North American
clients. He also teaches at the University
of Washington School of Design. Van Dyke's work has
been recognized in major design
journals and competitions around the world.

RICHARD DANNE
New York, New York
Serigraph

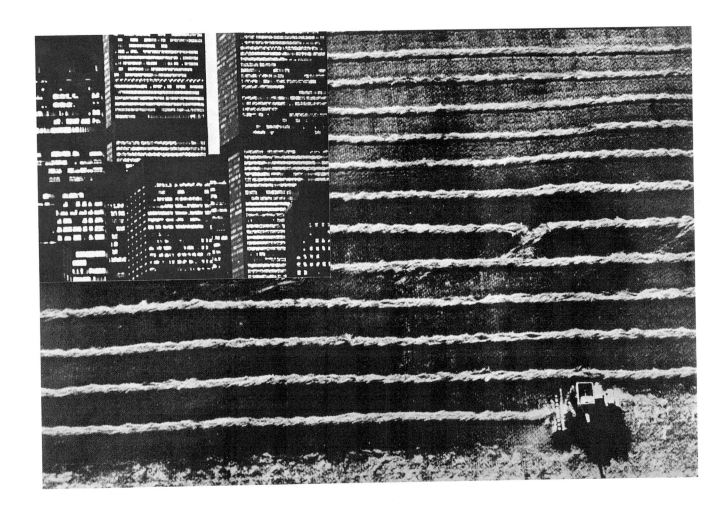

Richard Danne is
president and creative director of Richard Danne &
Associates, design consultants to major national
corporations and public institutions. Previously he was
a partner of Danne & Blackburn and has taught
at the School of Visual Arts. Among his many honors
is the Presidential Award for Design Excellence
presented by President Ronald Reagan. Danne is cur-
rent president of the U.S. delegation to the
Alliance Graphique Internationale and past president
of the AIGA.

DOUGLAS BOYD
Los Angeles, California
Ink on paper

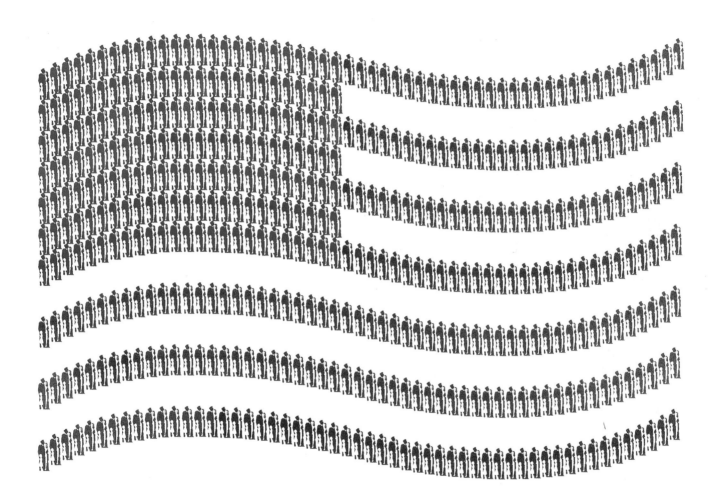

In 1970,
Douglas Boyd founded Douglas Boyd Design and
Marketing in Los Angeles, following years as a designer
for the Ford Motor Company. He has served as an
instructor at the University of California, Los Angeles, and
has lectured at California State University, Long Beach,
and the Art Center College of Design, where he also
served as vice-president of the alumni board.
Boyd is a recipient of a number of awards, including a
gold medal from the New York Art Directors Club.

MIKE HICKS
Austin, Texas
Enamel paint on wood

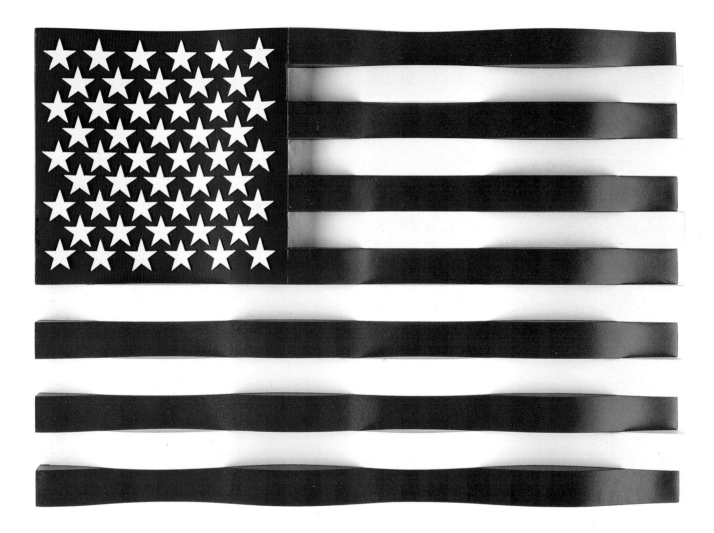

40

Award-winning
graphic designer Mike Hicks is president of Hixo.
Hicks is the author of *How to be Texan*
and *Yankees Made Simple/The South Made Simple*
and of numerous magazine articles. He
has also been the subject of several design articles
and is a frequent lecturer at design
organizations. His work is included in the permanent
archives of the Smithsonian Institution
and in the Museum of Modern Art in Colombia.

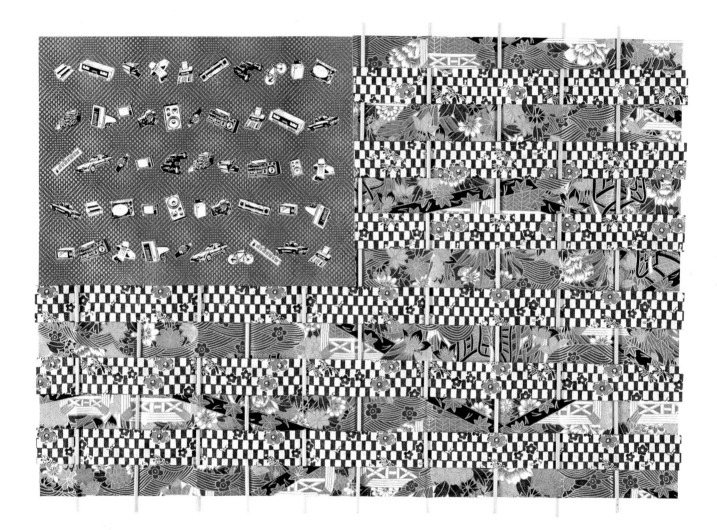

After graduating
with honors from the Art Center College of Design,
John Coy established COY, where he serves as
creative director. Coy teaches design at the Otis Parsons
School of Design in Los Angeles. He served
as founding president of the Los Angeles chapter of
the AIGA and currently sits on its board,
as well as on the advisory board of the Art Directors
Club of Los Angeles.

ANTHONY RUSSELL
New York, New York
Ink and paper collage

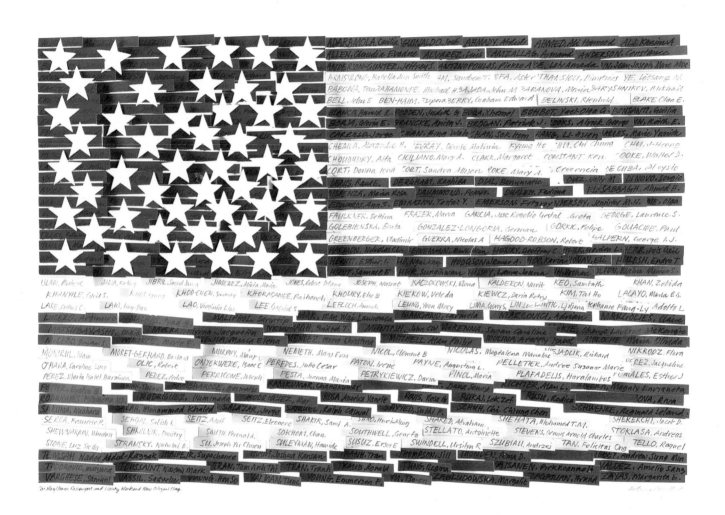

Born and educated
in London, Anthony Russell is head of Anthony Russell,
Inc., a New York design firm. This multi-
disciplinary office produces annual reports, posters,
catalogs, magazines, and environmental graphics
for national clients such as financial institutions,
development corporations, and museums.
Russell is currently the president of the New York
chapter of the AIGA.

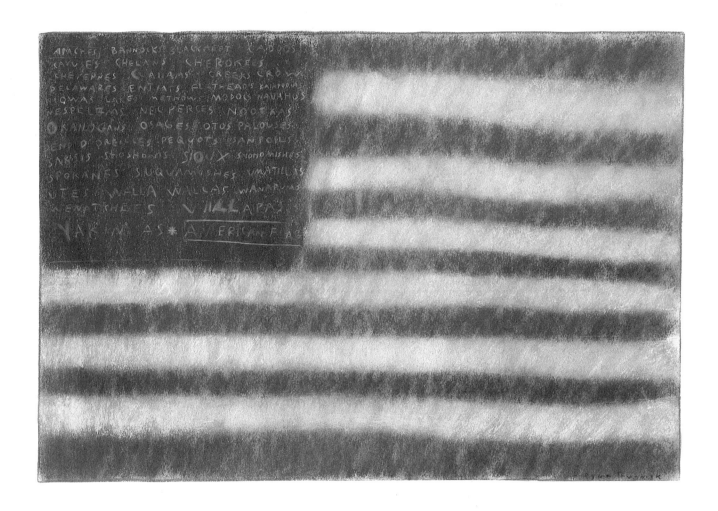

A frequent medalist
in design competitions, Regan Dunnick is best
recognized for his colorful, expressionistic editorial and
advertising illustrations. His work is represented
in the permanent collection of the Library of Congress
and has been featured in international design
magazines. In addition to his free-lance work, Dunnick
teaches illustration and graphic design at his
alma mater, the Ringling School of Art and Design.
He previously taught at Southwest Texas
State University and the Houston Institute of Art.

STEVE TOLLESON
San Francisco, California
Silkscreen/photo collage

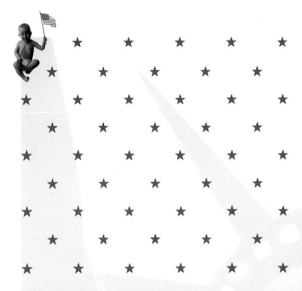

1814—The Star-Spangled Banner — Oh, say can you see, by the dawn's early light, What so proudly we hailed at the twilight's last gleaming, Whose broad stripes and bright stars, through the perilous fight, O'er the ramparts we watched were so gallantly streaming. And the rockets red glare, the bombs bursting in air, Gave proof through the night that our flag was still there. Oh, say, does that Star-Spangled Banner yet wave O'er the land of the free and the home of the brave? On the shore dimly seen through the mists of the deep, Where the foe's haughty host in dread silence reposes, What is that which the breeze, o'er the towering steep, As it fitfully blows, half conceals, half discloses? Now it catches the gleam of the morning's first beam, In full glory reflected now shines in the stream, 'Tis the Star-Spangled Banner, O long may it wave O'er the land of the free and the home of the brave! And where is that band who so vauntingly swore That the havoc of war and the battle's confusion, A home and a country should leave us no more? Their blood has washed out their foul footsteps' pollution. No refuge could save the hireling and slave From the terror of flight, or the gloom of the grave. An ★ Lyrics by Francis Scott Key. Music by John Stafford Smith

1831—America — My country 'tis of thee, Sweet land of liberty, Of thee I sing; Land where my fathers died, Land of the Pilgrims' pride, From ev'ry mountain side Let freedom ring. My native country, thee, land of the noble free, Thy name I love. I love thy rocks and rills, thy woods and templed hills, My heart with rapture thrills Like that above. Let music swell the breeze, and ring from all the trees Sweet freedom's song. Let mortal tongues awake, let all that breathe partake. Let rocks their silence break, The sound prolong. Our fathers' God to Thee, Author of liberty, To Thee we sing. Long may our land be bright with freedom's holy light. Protect us by Thy might, Great God, our King! My country 'tis of thee, Sweet land of liberty, Of thee I sing; Land where my fathers died, Land of the Pilgrims' pride. From ev'ry mountain side Let freedom ring. My native country, thee, name I love. I love thy rocks and rills, thy woods and templed hills. My heart with rapture thrills Like that above. Let music swell the breeze, and ring from all the trees Sweet freedom's song. Let mortal tongues awake, let all that breathe partake. Let rocks their silence break. The sound prolong. Our father ★ Lyrics by Samuel Francis Smith. Music by Henry Carey

1895—America the Beautiful — O beautiful for spacious skies, For amber waves of grain, For purple mountain majesties Above the fruited plain! America! America! God shed His grace on thee, And crown thy good with brotherhood From sea to shining sea! O beautiful for Pilgrim feet, Whose stern impassioned stress A thoroughfare for freedom beat Across the wilderness. America! America! God mend thine every flaw, Confirm thy soul in self-control, Thy liberty in law. O beautiful for heroes proved In liberating strife, Who more than self their country loved, And mercy more than life. America! America! May God thy gold refine Till all success be nobleness And every gain divine. O beautiful for patriot dream That sees beyond the years, Thine alabaster cities gleam Undimmed by human tears. America! America! God shed His grace on thee, And crown thy good with brotherhood From sea to shining sea. O beautiful for spacious skies, For amber waves of grain, For purple mountain majesties Above the fruited plain! America! America! God shed His grace on thee, And crown thy good with brotherhood From sea to shining sea! O beautiful for Pilgrim feet, Whose stern impassioned stress A thoro ★ Lyrics by Katherine Lee Bates. Music by Samuel A. Ward

1956—This Land is Your Land — As I was walking that ribbon of highway, I saw above me that endless skyway, I saw below me that golden valley. This land was made for you and me. This land is your land, this land is my land, From California to the New York island. From the redwood forest to the gulf-stream waters. This land was made for you and me. I roamed and rambled, and I followed my footsteps, To the sparkling sands of her diamond deserts, And all around me a voice was sounding. This land was made for you and me. This land is your land, this land is my land, From California to the New York island, From the redwood forest to the gulf-stream waters. This land was made for you and me. When the sun comes shining, then I was strolling, And the wheat fields waving, and the dust clouds rolling. A voice was chanting as the fog was lifting. This land was made for you and me. This land is your land, this land is my land, From California to the New York island, From the redwood forest to the gulf-stream waters. This land was made for you and me. As I was walking that ribbon of highway, I saw above me that endless skyway, I saw below me that golden valley. This land was made for you and me. This land is your land, ★ Lyrics and Music by Woody Guthrie

1963—Surfin' U.S.A. — If everybody had an ocean across the U.S.A., then everybody'd be surfin' like California. You'd see them wearin' their baggies, huarachi sandals too. A bushy bushy blonde hairdo. Surfin' U.S.A. You'll catch 'em surfin' at Del Mar, Ventura County Line, Santa Cruz and Tressels, Australia's Narabine. All over Manhattan and down Doheny way. Ev'rybody's gone surfin', Surfin' U.S.A. We'll all be gone for the summer, we're on safari to stay. Tell the teacher we're surfin'. Surfin' U.S.A. At Haggarty's and Swami's, Pacific Palisades, San Onofre and Sunset, Redondo Beach, L.A. All over La Jolla, at Waiamea Bay, Ev'rybody's gone surfin', Surfin' U.S.A. If everybody had an ocean across the U.S.A., then everybody'd be surfin' like California. You'd see them wearin' their baggies, huarachi sandals too. A bushy bushy blonde hairdo. Surfin' U.S.A. You'll catch 'em surfin' at Del Mar, Ventura County Line, Santa Cruz and Tressels, Australia's Narabine. All over Manhattan and down Doheny way. Ev'rybody's gone surfin', Surfin' U.S.A. We'll all be gone for the summer, we're on safari to stay. Tell the teacher we're surfin'. Surfin' U.S.A. If everybody had an ocean across the U.S.A. then everybody'd be surfin' like California. You'd see them wearin' their baggies, huarachi sandals too. A bushy bushy blonde hairdo. Surfin' U.S.A. You'll catch 'em surfin' at Del Mar, Ventura County Line, Santa Cruz and Tressels, Australia's Narabine. All over Manhattan and down Doheny way. Ev'rybody's gone surfin', Surfin' U.S.A. We'll all be plannin' out a route — we're gonna take real soon, we're waxin' down our surfboards, we can't wait for June. We'll all be gone for the summer, we're on safari to stay. Tell the teacher we're surfin'. Surfin' U.S.A. At Haggarty's and Swami's, Pacific Palisades, San Onofre and Sunset. ★ Lyrics by Brian Wilson. Music by Chuck Berry

1959—Back in the U.S.A. — Oh, well, oh, well, I feel so good today, We just touched ground on an international runway, Jet propelled back home, from overseas to the U.S.A. New York, Los Angeles, oh, how I yearned for you, Detroit, Chicago, Chattanooga, Baton Rouge. Let alone just to be at my home back in ol' St. Lou. Did I miss the skyscrapers, did I miss the long freeway? From the coast of California to the shores of the Delaware Bay. You can bet your life I did, till I got back to the U.S.A. Looking hard for a drive-in, searching for a corner cafe, Where hamburgers sizzle on an open grill night and day, Yeah, and a juke-box jumping with records like in the U.S.A. Well, I'm so glad I'm livin' in the U.S.A., Yes, I'm so glad I'm livin' in the U.S.A., Anything you want, we got it right here in the U.S.A. Oh, well, oh, well, I feel so good today, We just touched ground on an international runway, Jet propelled back home, from overseas to the U.S.A. New York, Los Angeles, oh, how I yearned for you, Detroit, Chicago, Chattanooga, Baton Rouge. Let alone just to be at my home back in ol' St. Lou. Did I miss the skyscrapers, did I miss the long freeway? From the coast of California to the shores of the Delaware Bay. You can bet your life I did, till I got back to the U.S.A. Looking hard for a drive-in, searching for a corner cafe, Where hamburgers sizzle on an open grill night and day, Yeah, and a juke-box jumping with records like in the U.S.A. Well, I'm so glad I'm livin' ★ Lyrics and Music by Chuck Berry

1985—Justice and Independence '85 — He was born on the fourth day of July So his parents called him Independence Day He married a girl named Justice who gave birth to a son called Nation. Then she walked away, Independence he would daydream and he'd pretend That some day him and Justice and Nation would get together again But Justice held up in a shotgun shack And she wouldn't let nobody in So a Nation cried Oh Oh When a Nation cries His tears fall down like missiles from the skies Justice look into Independence's eyes Can you make everything alright Can you keep your Nation warm tonight Well Nation grew up and got himself a big reputation Couldn't keep the boy at home no no He just kept running 'round and 'round and 'round Independence and Justice well they felt so ashamed When the Nation fell down they argued who was to blame Nation cries His tears fall down like missiles from the skies Justice look into Independence's eyes Can you make everything alright Can you keep your Nation warm tonight Well the Country Everybody come along When you're feelin' down yeah yeah Just sing this song yeah yeah He was born on the fourth day of July So his parents called him Independence Day He married a girl named Justice who gave birth to a son called Nation. Then she walked away, Independence he would daydream and he'd pretend That some day him and Justice and Nation would get together again But Justice held up in a shotgun shack And she wouldn't let nobody in So a Nation cried Oh Oh When a Nation cries His tears fall down like missiles from the skies Justice look into Independence's eyes Can you make everything alright Can you keep your Nation warm tonight Well Nation grew up and got himself a big reputation Couldn't keep the boy at home no no Oh When a Nation cries His tears fall down like missiles from the skies 'round and 'round and 'round Independence and Justice well they felt so ashamed When the Nation fell down they argued who was to blame Nation if you'll just come home we'll have this family again Oh Oh When a Nation don't cry Oh Oh When a Nation cries His tears fall down like missiles from ★ Lyrics and Music by John Mellencamp

Following completion of a
fine arts and graphic design degree from California
State University, Chico, in 1981, Steve Tolleson
established Tolleson Design in San Francisco in 1984.
The firm's projects include annual reports,
marketing collateral, corporate identity, and packaging.
Tolleson's work has been featured in design
publications and in the Mead Annual Report Show.

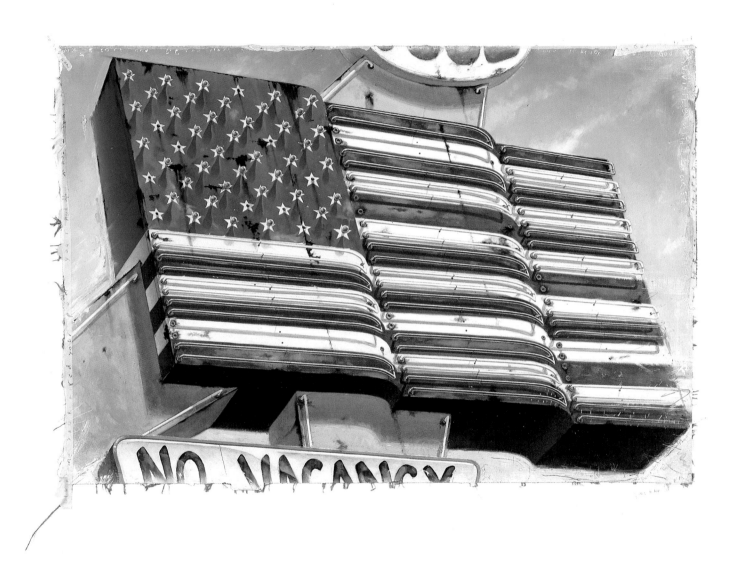

David Linn
studied illustration on scholarship at Brigham Young
University. Upon graduating in 1986, he
established a studio with fellow illustrator Brian Andre
in Irvine, California. Linn has produced work
for various books, magazines, and newspapers across
the country, as well as for private collections.
His illustrations have been featured in several leading
design publications.

PIPER MURAKAMI
San Francisco, California
Serigraph

6

A graduate of the
design program at California State University,
Chico, Piper Murakami is a graphic
designer with Steinhilber and Deutsch, which
specializes in corporate identification
and packaging design. She is also an affiliate of
the Bow Wow House of San Francisco.
Murakami previously worked with Michael
Vanderbyl Design.

Jack Unruh's
illustrations have appeared in numerous magazines,
corporate annual reports, and national
exhibits, as well as in the Smithsonian Institution's
book series. A longtime free-lancer based in
Dallas, Unruh was an adjunct professor of drawing
and illustration at East Texas State University
from 1969 to 1978. His work is showcased in *Advertising
Art in America* and *200 Years of American Illustration.*

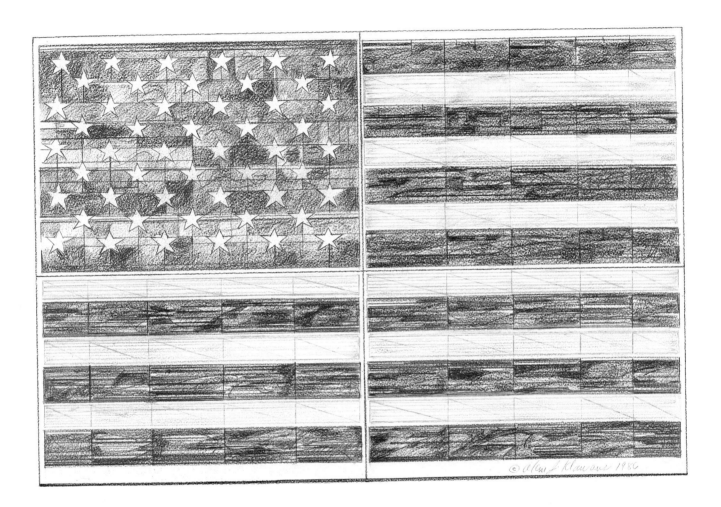

Former director
of design for SmithKline Beckman Corporation,
Alan Klawans is also a fine artist whose
work has been exhibited in museums around the
country, including the Whitney Museum
of American Art, the Corcoran Gallery,
and the Boston Museum of Fine Arts.
Examples of his design have been featured in
major national exhibits.

RON SULLIVAN
Dallas, Texas
Cloth assemblage

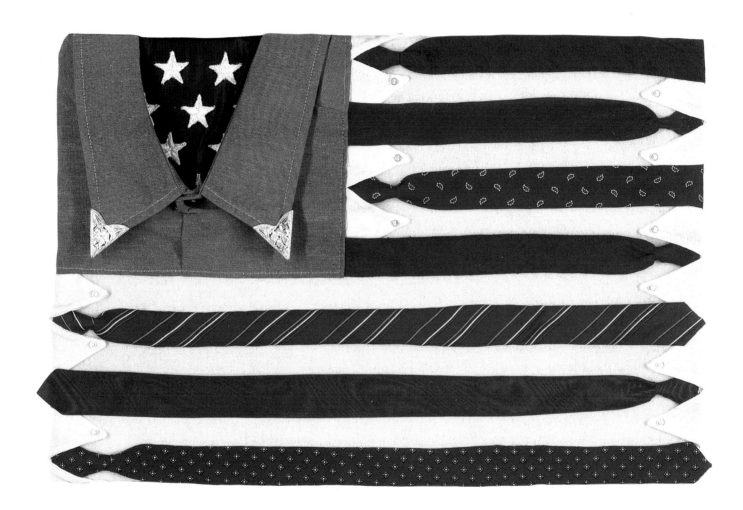

Ron Sullivan
cofounded Sullivan Perkins with Mark Perkins in 1984.
Previously he was a principal in the design firm
Richards, Sullivan, Brock and Associates. Sullivan's
work as an art director, designer, and illustrator
has been honored in major national and
international advertising and design competitions.
He is a frequent guest lecturer at universities
and professional organizations.

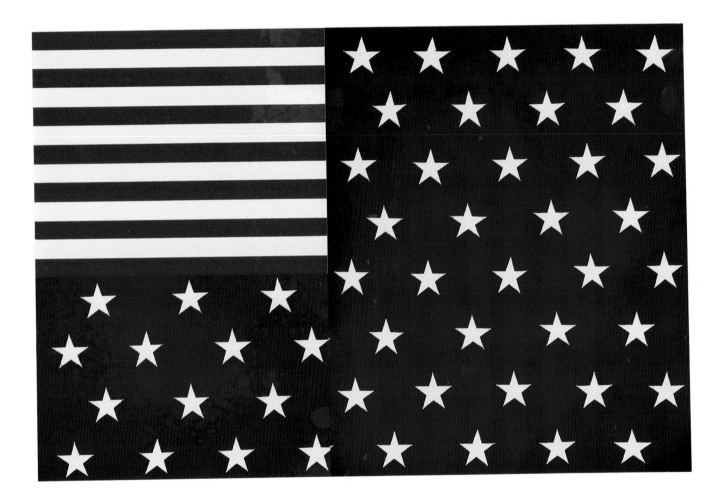

A Fulbright scholar
and cofounder of Push Pin Studio, Milton Glaser is
one of the world's most celebrated designers.
Cofounder of *New York* magazine, illustrator and author
of more than half a dozen books, design
consultant on major publications ranging from the
Village Voice to *L'Express*, and designer for
the World Trade Center Observation Deck and Grand
Union supermarkets, Glaser has been honored
with one-man exhibitions, honorary doctorate degrees,
and countless international accolades for
design achievement.

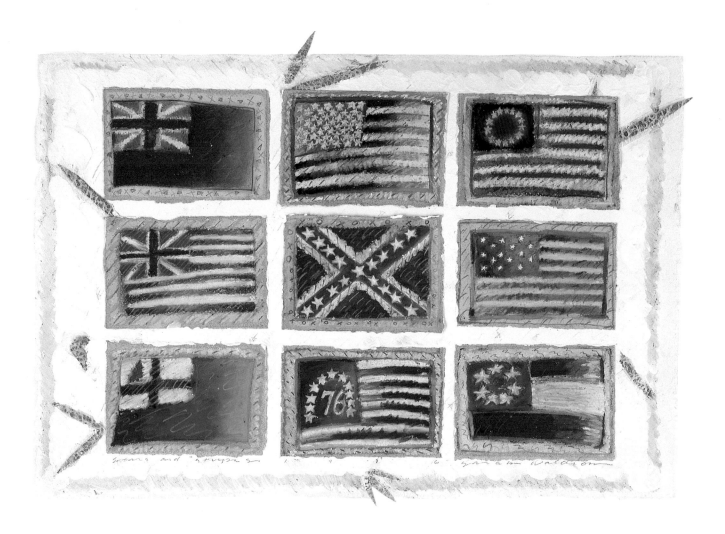

Sarah Waldron
worked for a number of years as a staff designer and
art director before pursuing a career as
an illustrator. She has produced award-winning
illustrations for a variety of corporate
and advertising clients. During her career as a
designer, she worked with John Van Dyke in
Seattle and Primo Angeli and S & O Consultants
in San Francisco.

BART CROSBY
Chicago, Illinois
Sewn cloth assemblage

2

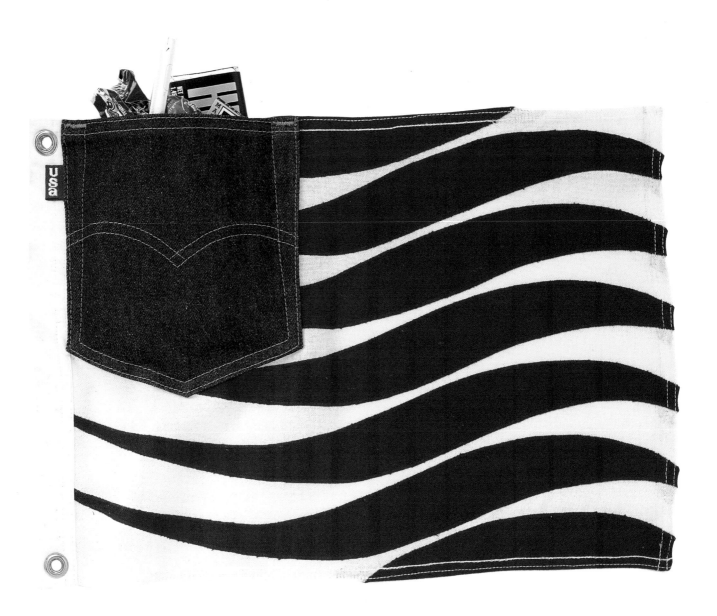

Bart Crosby is
president of Crosby Associates, a Chicago-based
design firm, that specializes in corporate
communications. Crosby's work has garnered many
major international design awards, and
examples of his work have appeared in leading design
publications. He has served as a vice-president
and director of the AIGA.

ALINA WHEELER
Philadelphia, Pennsylvania
Cut paper collage

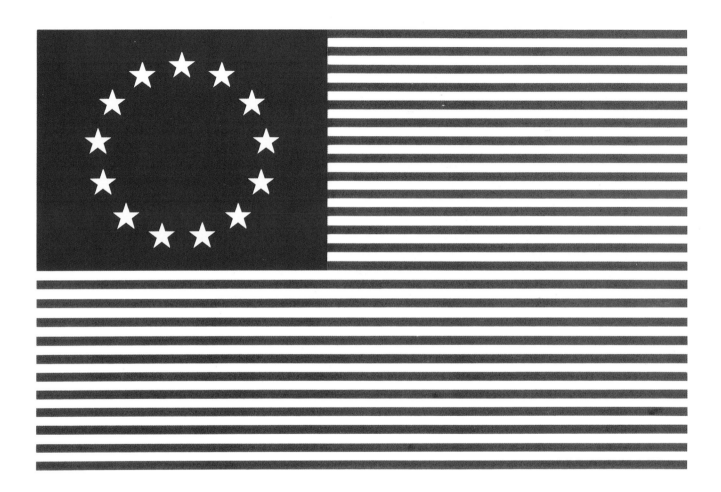

A graduate of
the Philadelphia College of Art, Alina Wheeler is now
a partner in Katz Wheeler Design, which
produces annual reports, promotional materials, and
corporate identity programs for a variety of
corporate, public, and institutional clients. Wheeler
received the Marcel Vertes Award for drawing
while studying at Philadelphia College of Art. Her
work has been represented in several leading
design publications.

DANIEL PELAVIN
New York, New York
Proto-color

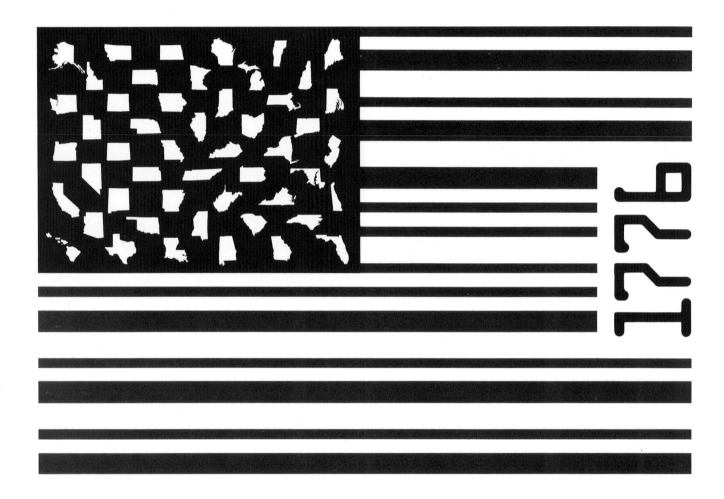

Daniel Pelavin
received his training in art studios in Detroit.
Since 1979, he has worked for clients
in publishing, advertising, and graphic design
from his studio in New York City.
Pelavin's work has been included in *Outstand-
ing Illustrators Today*, Volume 2, and
featured in many publications and exhibitions.

KEN THOMPSON
Atlanta, Georgia
Enamel on wood

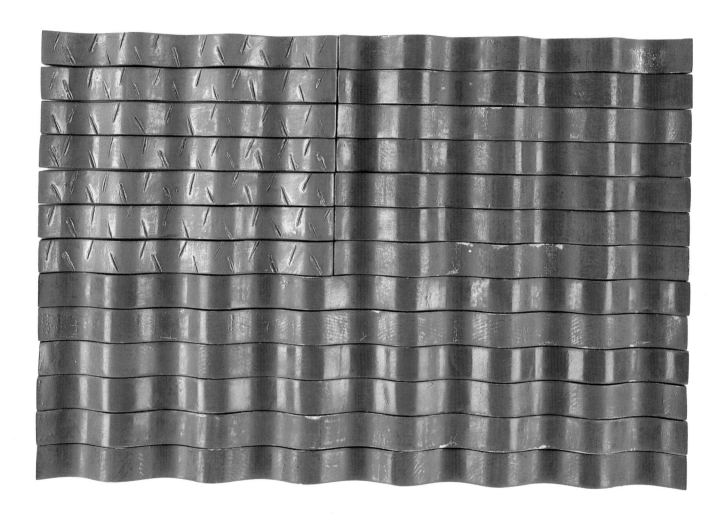

After a stint as
a graphic designer in New York City, Ken Thompson
moved to his native Atlanta to work as an
independent designer. Thompson handles a variety
of design assignments for national corporations.
In recent years he has developed a keen interest in
dimensional art projects, which give him
hands-on involvement in the design, mounting, and
installation of structures and exhibits.

LOUISE FILI
New York, New York
Serigraph

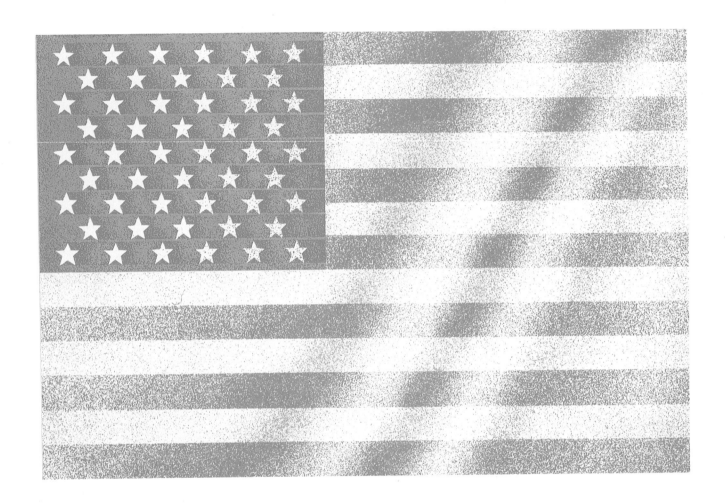

Louise Fili
designs book jackets in her role as art director for
Pantheon Books. Prior to joining Pantheon
in 1978, Fili was senior designer at Herb Lubalin
Associates. She teaches a senior portfolio
course at the School of Visual Arts and the Cooper
Union and has received numerous awards for
design and illustration, including the New York Art
Directors Club gold and silver medals.
In 1984, Fili received a grant from the National
Endowment for the Arts.

MICHAEL SCHWAB
San Francisco, California
Serigraph

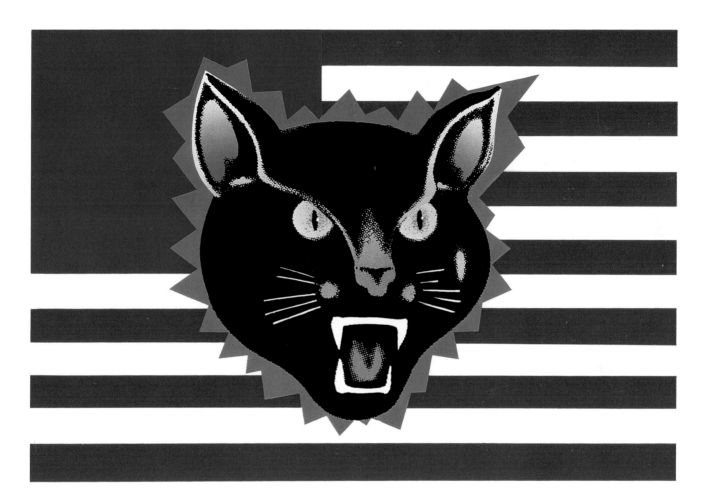

JULY '86 SCHWAB

A native of Oklahoma,
Michael Schwab is credited with being one of the
originators of the "California look"—dramatic
perspectives, large, flat areas of color, spontaneous
style. Principal of Michael Schwab Design, he
produces award-winning designs for a broad range of
international clients and has been featured in
prestigious design publications. Schwab is a graduate
of the Art Center College of Design.

8

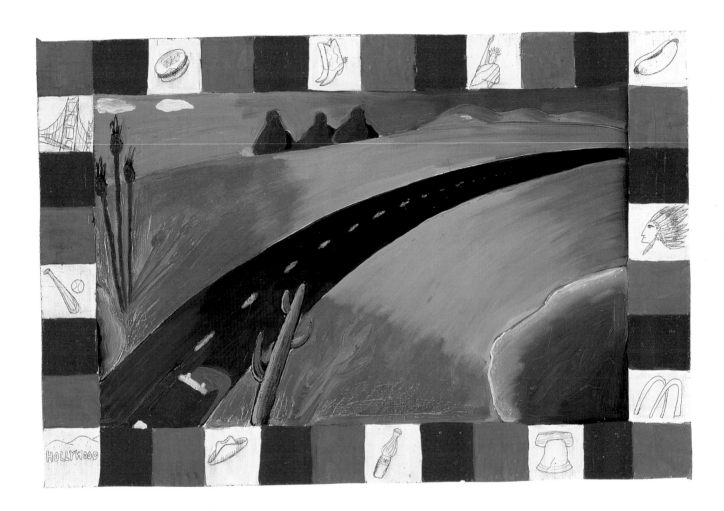

Mercedes McDonald
is a painter and illustrator whose clients include
Fortune 500 companies and national
publications. Her paintings and drawings have
been presented in a number of
exhibitions in the San Francisco Bay Area.
McDonald received her master of fine arts
in painting from the San Francisco Art Institute.

CHRISTOPHER PULLMAN
Boston, Massachusetts
Watercolor on Xerox

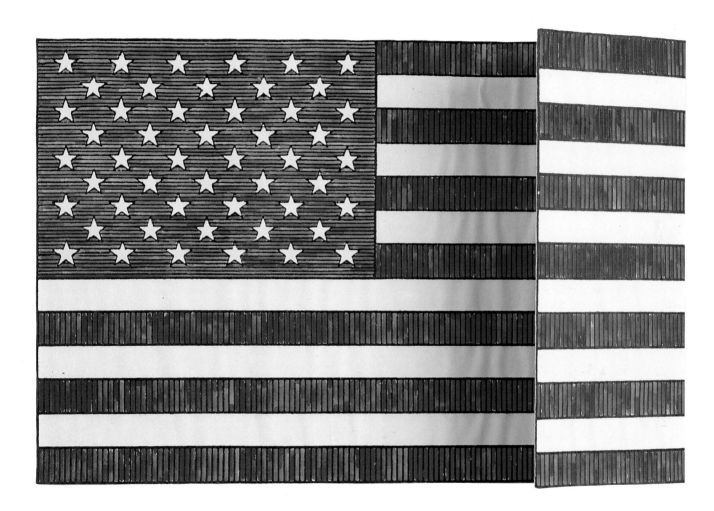

5

Christopher Pullman
is manager of design for WGBH, Public Television in
Boston. In 1986, Pullman's direction
won WGBH the AIGA Design Leadership Award.
Before joining WGBH in 1973, Pullman
operated a design practice in New Haven, Connecticut,
and worked as a consultant to George Nelson
in New York. From 1976 to 1986, Pullman served on
the board of the Design Management Institute.

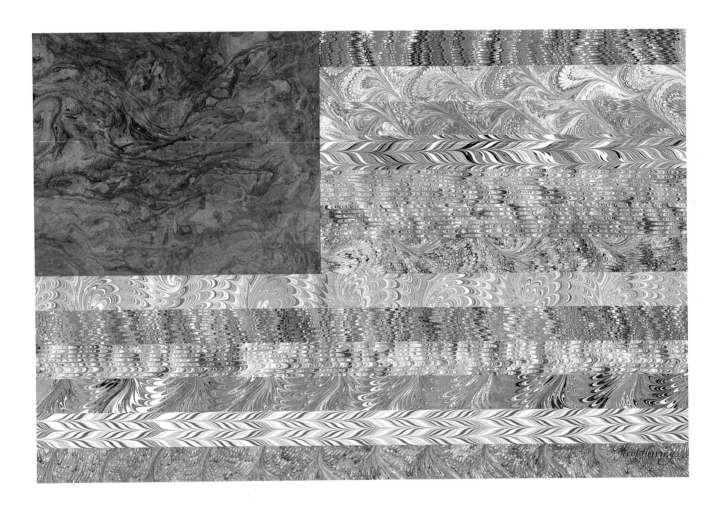

A graduate of
the Kansas City Art Institute, Jerry Herring is the
principal of Herring Design. For a period,
he was in partnership with designer Woody Pirtle under
the name Herring & Pirtle. In 1984, Herring
and his wife, Sandy, founded two publishing companies,
Herring Press and Graphic Design Press,
to produce book projects. His work for corporate and
editorial clients has been featured in
national and international design publications.

JOHN CRAIG
Soldiers Grove, Wisconsin
Paper collage

John Craig's
illustrations have appeared on television and record
albums and in the *Encyclopedia Britannica*,
corporate reports, magazines, books, and newspapers.
Craig holds fine arts degrees from Rochester
Institute of Technology and the School of the Art
Institute of Chicago. Before becoming a
free-lance illustrator in 1968, he served as art director
at Mercury Records.

KINUKO Y. CRAFT

Norfolk, Connecticut

Watercolor and oil on board

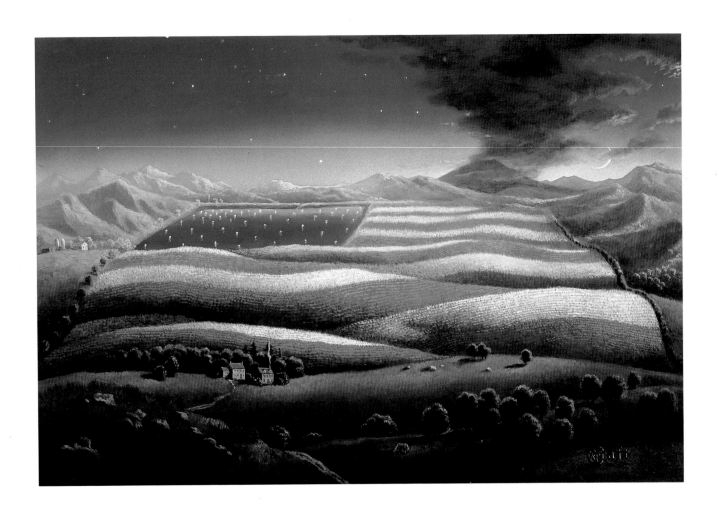

Born and educated
in Japan, Kinuko Yamabe Craft came to the United
States in 1964 to study at the School of the
Art Institute of Chicago. Craft's illustrations for
advertising, corporate, and editorial clients
have won major awards, including the New York Art
Directors Club gold medal. Recently, the
Society of Illustrators presented her work in a
one-woman show.

KIT HINRICHS
San Francisco, California
Brass and magnesium construction

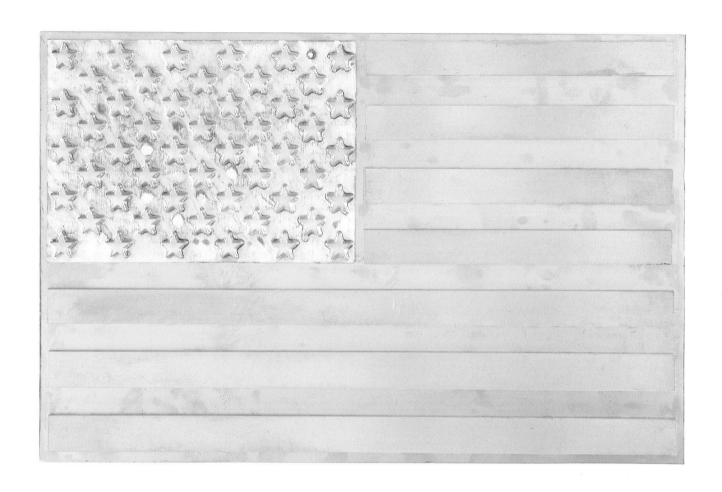

Prior to
becoming a partner of Pentagram, Kit Hinrichs was a
principal of Jonson Pedersen Hinrichs & Shakery.
His graphic design for corporate clients has received
hundreds of coveted awards. Hinrichs has
taught at the School of Visual Arts and the Academy
of Art College. He is coauthor of the book
Vegetables. His work is included in the permanent col-
lection of the Museum of Modern Art. Hinrichs
serves as an executive board member of the AIGA.

4

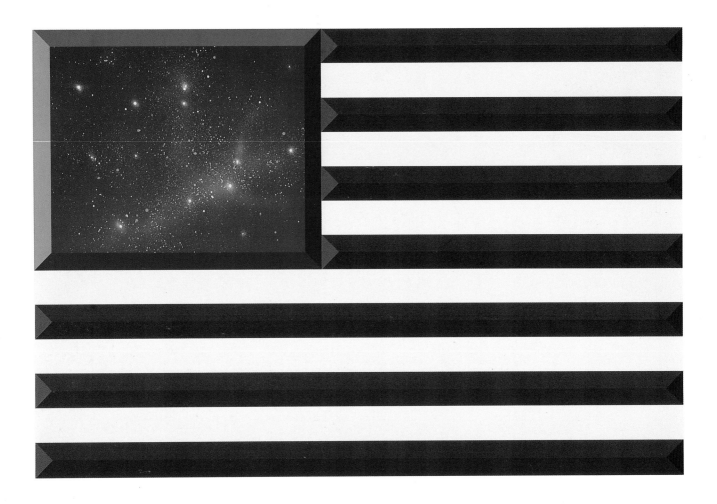

After launching his
career as a staff designer for CBS in New York, Gerard
Huerta started Gerard Huerta Design and
eventually moved his offices to Darien, Connecticut.
Huerta has won several awards for his work,
which is based largely on a combination of illustration
and hand-lettered typography. Some of his
logotypes include the mastheads of *Time*, *The Atlantic*,
and *Money* magazine.

LISSA ROVETCH
San Francisco, California
Mixed media construction

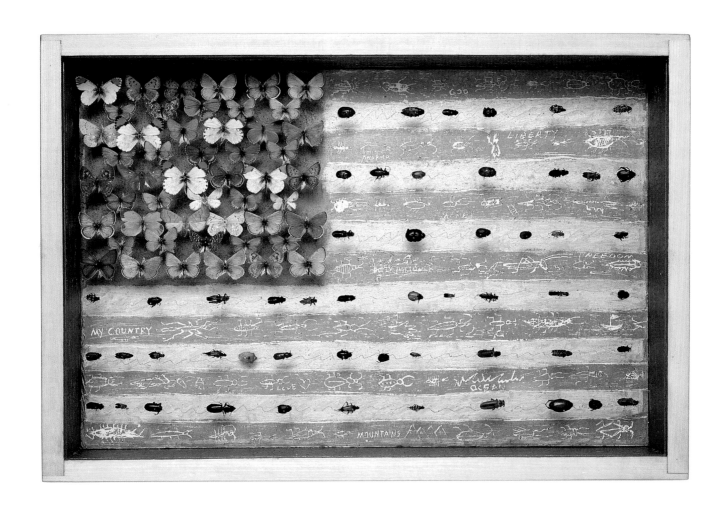

Lissa Rovetch
studied and worked in Paris and New York.
She received a bachelor of fine arts
degree from Parsons School of Design, before
moving to San Francisco. Her recent
free-lance assignments bring a fine-arts perspec-
tive to commercial projects, which
have ranged from artwork for airline interiors
to magazine illustrations.

HENRY BRIMMER
San Francisco, California
Mixed media on Astroturf

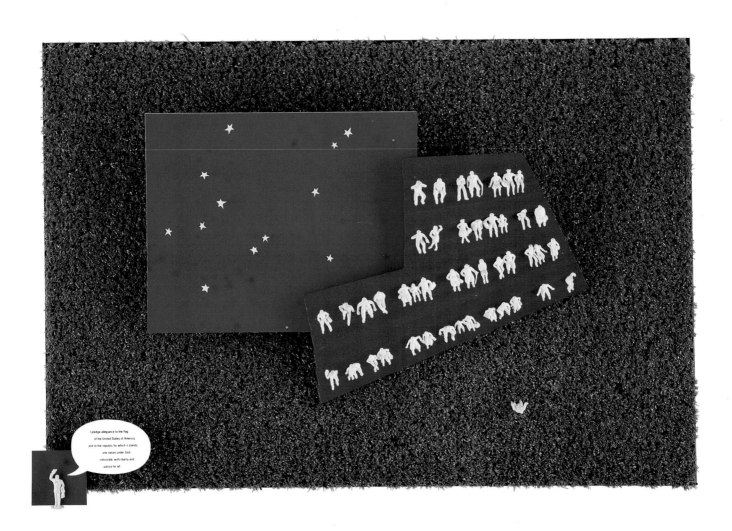

6

Henry Brimmer
is the principal of Henry Brimmer Design and
Advertising and the publisher of
Photo Metro magazine. He also teaches at
the Academy of Art College.
Brimmer has won several awards from major
national design associations, includ-
ing the AIGA, the New York Art Directors Club,
and the Society of Typographic Arts.

DAVID HILLMAN
London, England
Cut paper

David Hillman,
a partner of Pentagram since 1978, has played a key
role in the design of several of Europe's major
publications, including *Le Matin de Paris*. Hillman's
work has been exhibited at the University of
Essen in West Germany and the Victoria and Albert
Museum and the Whitechapel Gallery in
London. He is a member of the Alliance Graphique
Internationale and a fellow of the Society
of Industrial Artists and Designers. Hillman has won
many coveted awards, including honors for
his design on the much acclaimed *English Sunrise*.

MICHAEL PATRICK CRONAN
San Francisco, California
Paper collage

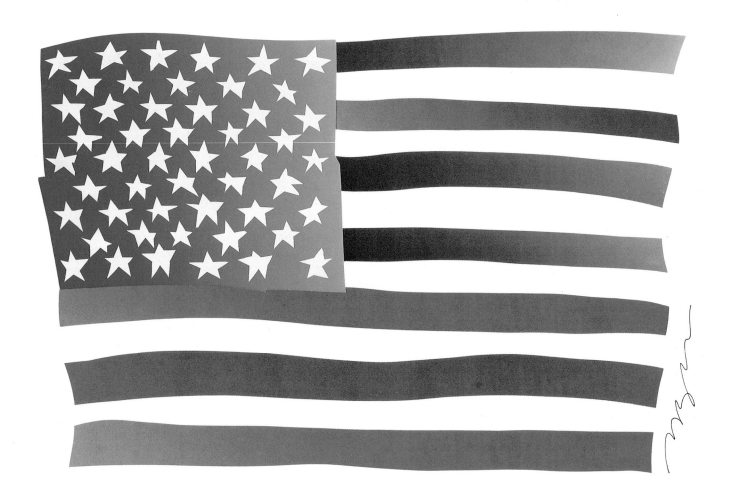

Michael Patrick
Cronan is principal of Cronan Design, which special-
izes in corporate communications and
environmental design. Cronan's award-winning work
has been represented in major design
annuals and shows and is in the permanent collections
of the Library of Congress, the Smithsonian
Institution, and the National Geographic Society.
He teaches at the California College
of Arts and Crafts and serves as a board member
of the Pickle Family Circus.

GERALD REIS
San Francisco, California
White pine and fir construction

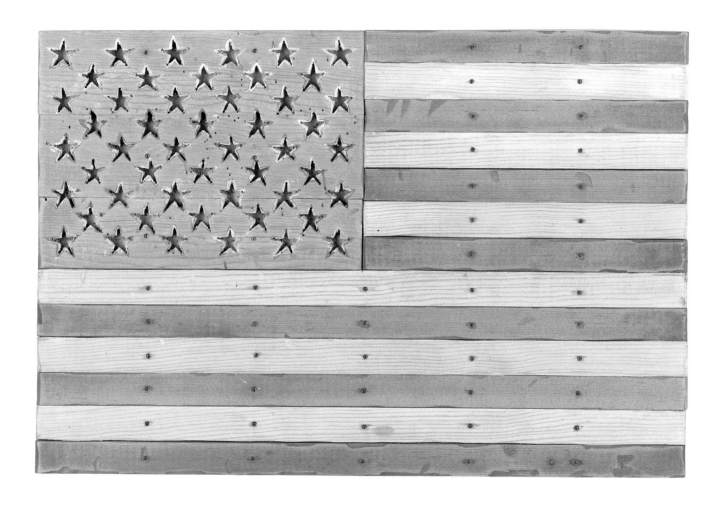

Gerald Reis heads
Gerald Reis & Company, a multi-disciplinary
firm handling print graphics and envi-
ronmental, product, and package design. Reis
has received many major design awards
and has been published in numerous leading
design journals. He was also recently
featured in the book *Seven Graphic Designers*.

STEVEN SOSHEA
San Francisco, California
Computer-generated Cibachrome

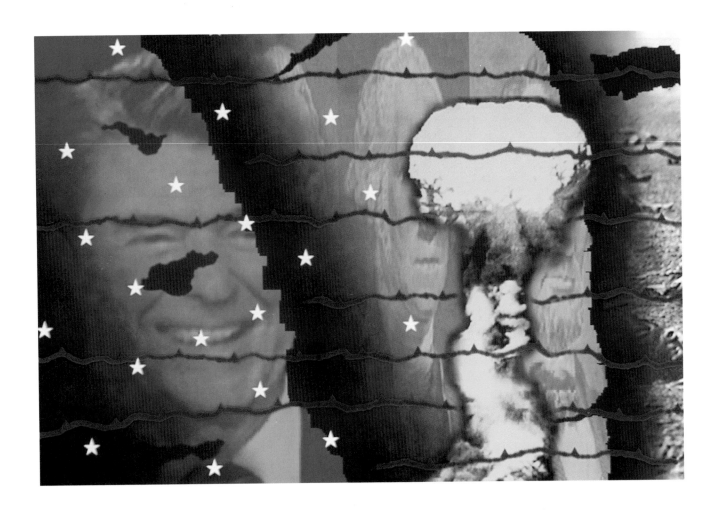

Steven Soshea has
a bachelor of fine arts in general design from
the California College of Arts and
Crafts. In 1986, he established Steven Soshea
Design, specializing primarily in
corporate communications. In 1987, Soshea
received the Business Arts Award
from the San Francisco Chamber of Commerce.

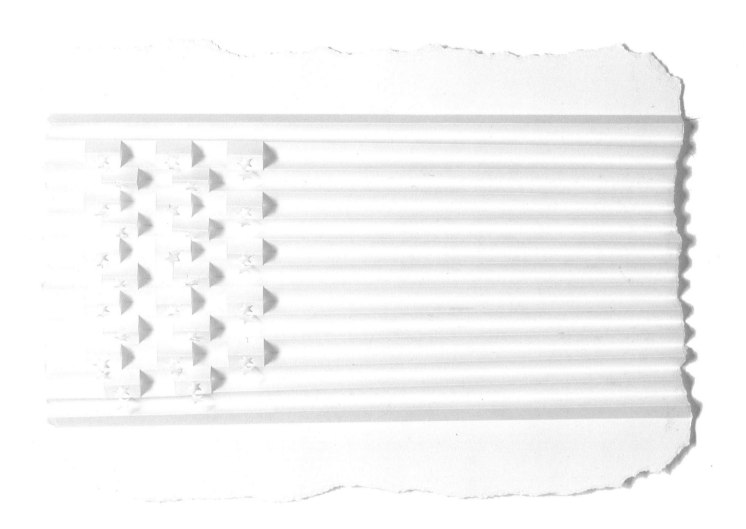

Laura Coe
graduated from Kent State University and later studied
under famed designers Armin Hoffmann,
Paul Rand, and Wolfgang Weingart in Switzerland.
After moving to San Diego, Coe worked as a
free-lance graphic designer, then joined International
Male as senior art director before opening her
own firm, Laura Coe Design.

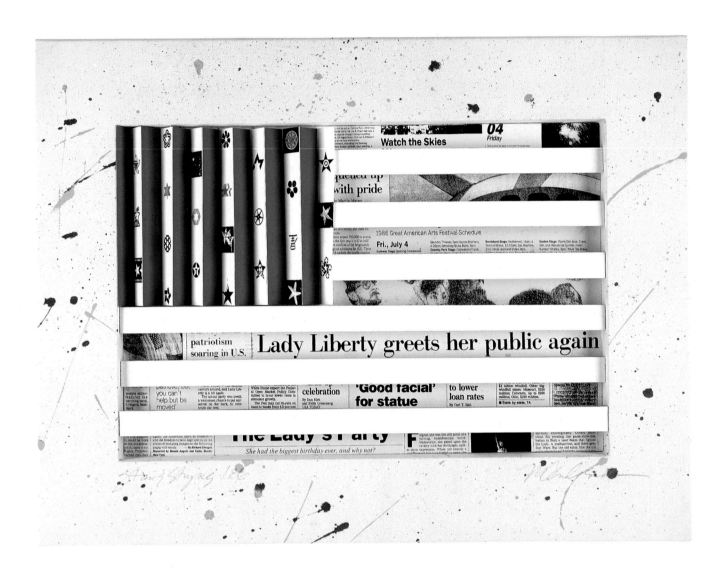

Mark Anderson
graduated from the Minneapolis College of Art and
Design and studied industrial design at the
Rietveldt Academie in Amsterdam. Since then,
Anderson has produced notable exhibits,
advertising and corporate communications, and
environmental designs for clients nation-
wide. His firm, Mark Anderson Design, is a consistent
winner at national design competitions.

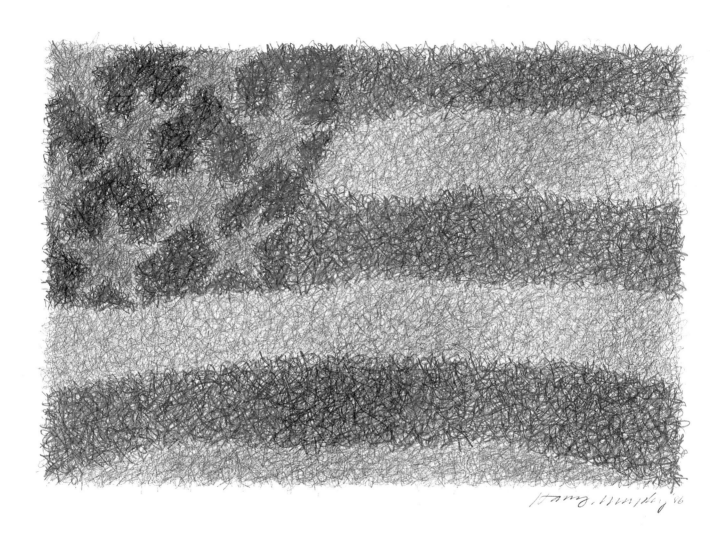

Harry Murphy
heads the design firm of Harry Murphy + Friends,
which handles a wide variety of assignments,
including corporate identity, print graphics, packaging,
advertising, exhibition design, architectural
graphics, interior design, color consulting, and environ-
mental art. Over the past thirty years, Murphy
has won more than 850 design awards in regional,
national, and international competitions.

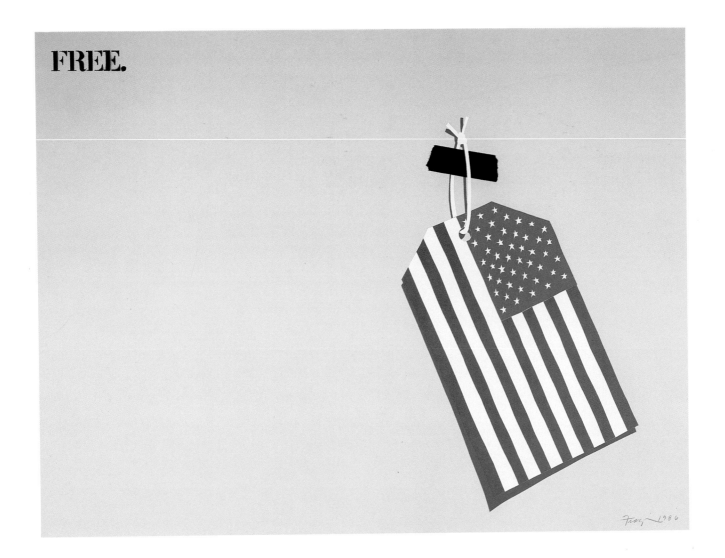

4

Craig Frazier
is the principal designer at Frazier Design
in San Francisco. His firm,
founded in 1980, specializes in marketing
design and communications.
Frazier is a lecturer at the California College
of Arts and Crafts and is an officer
of the San Francisco chapter of the AIGA.

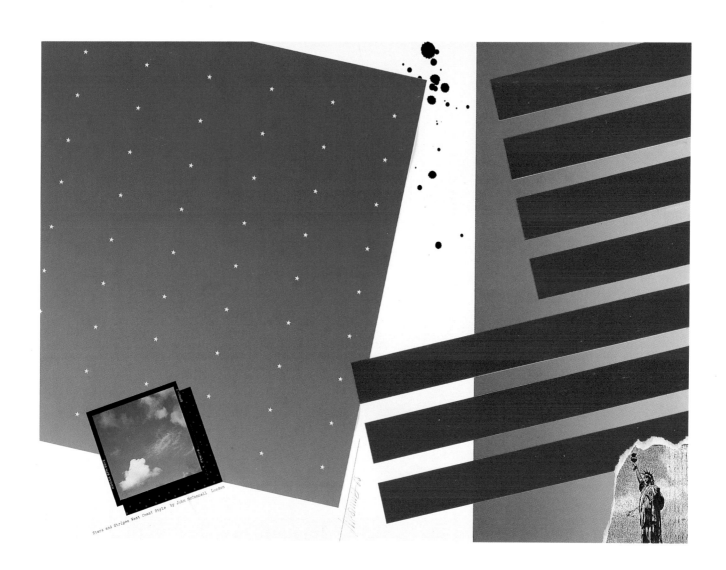

As a partner of
Pentagram, John McConnell has developed many notable
corporate identity programs. He also acts
as consultant on major projects, including serving as
main board director for Faber & Faber Publishers.
He is a member of the British Post Office Stamp Ad-
visory Committee and the Alliance Graphique
Internationale. In 1985, he received the Designers and
Art Directors Association President's Award.

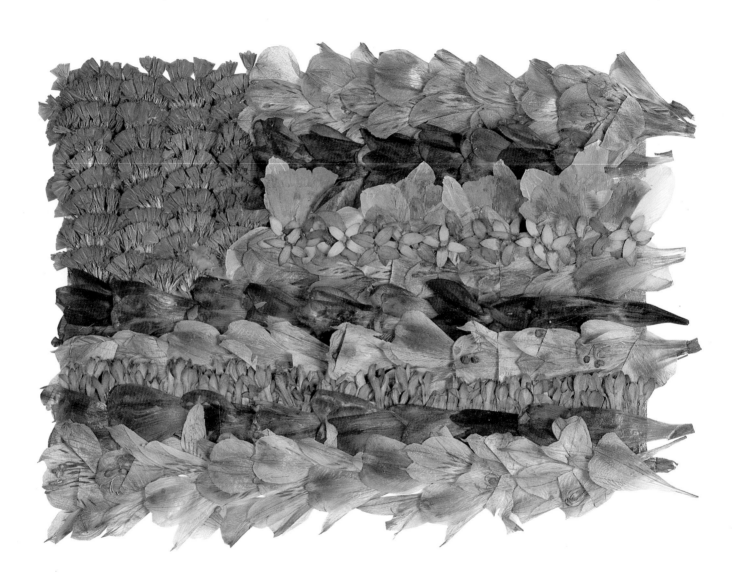

Amy Hoffman
graduated in 1985 with a bachelor's degree in
fine arts from Scripps College in
Claremont, California. Since then she has
worked in the San Francisco office of
Pentagram and has been associated with the
California College of Arts and Crafts.

JOYCE KITCHELL
San Diego, California
Watercolor on paper

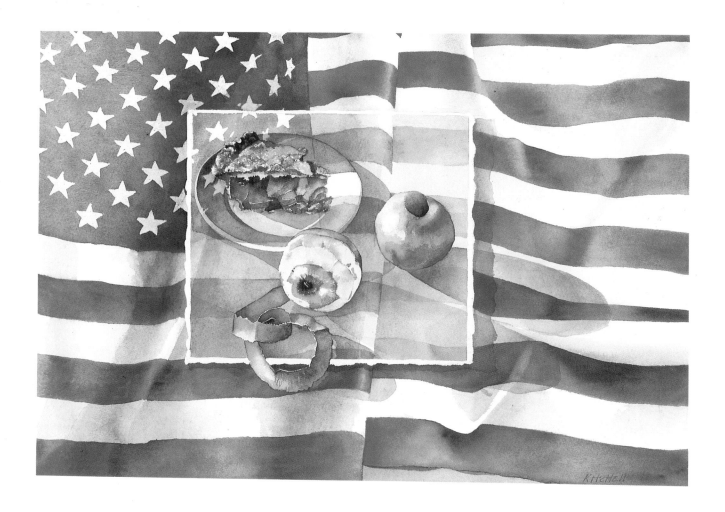

Joyce Kitchell has
been a professional illustrator since 1972, creating
artwork for both advertising and editorial
clients across the country. In addition to illustration,
Kitchell produces commissioned work for
private art collectors in southern California. Her
images have been featured in the Society
of Illustrators annuals.

WILBURN BONNELL
New York, New York
Paper construction

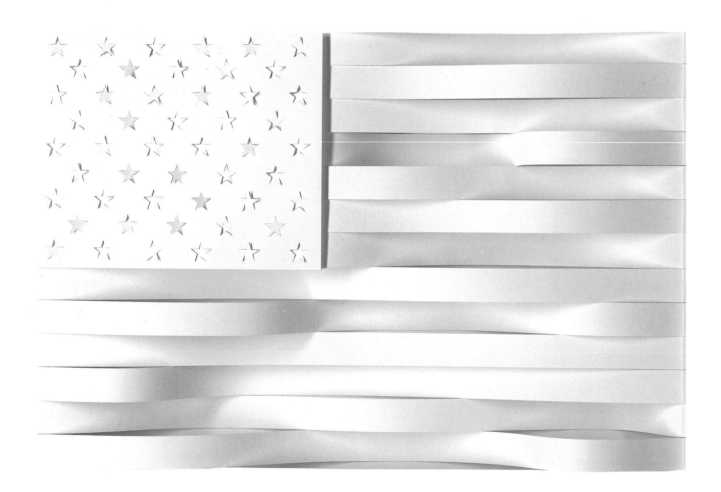

After managing
design programs at Container Corporation of America
and J.C. Penney, Wilburn Bonnell formed
Bonnell Design Associates. His work, which has been
featured in numerous publications and
exhibitions, has won more than two hundred awards,
including the New York Art Directors Club
gold medal. In addition, his posters are in the
permanent collection of the Museum of
Modern Art. Bonnell is a member of the Alliance
Graphique Internationale, a director of
the AIGA, and has been involved with the Federal
Design Improvement program.

ALAN PECKOLICK
New York, New York
Paper collage

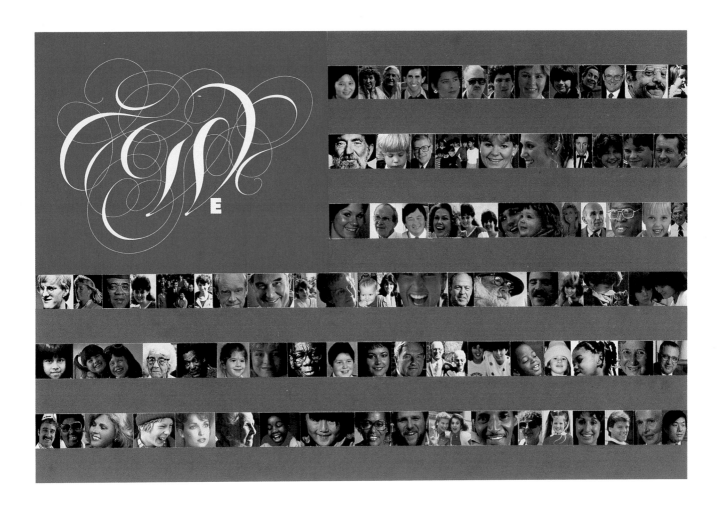

Previously a
director of The Pushpin Group, Alan Peckolick is
now president of Peckolick & Partners.
Widely recognized for his elegant typographic designs,
Peckolick produces graphic design for
corporations around the world. As a recipient of many
prestigious awards, he is a frequent
juror and guest lecturer at art schools and professional
organizations. His work has been exhibited
in galleries worldwide and is part of the permanent
collection of the Gutenberg Museum in
West Germany. Peckolick is a member of the Alliance
Graphique Internationale.

LAWRENCE BENDER
Palo Alto, California
Paint, nuts, and bolts on board

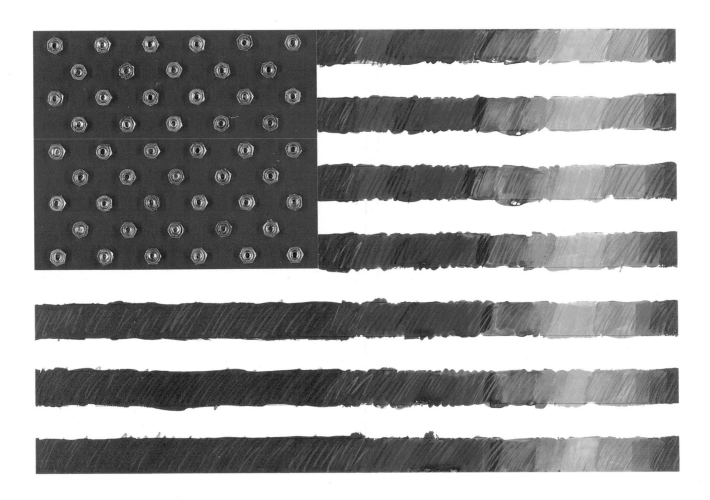

Lawrence Bender is
the principal of Lawrence Bender & Associates,
which focuses primarily on corporate
design and annual reports. The firm has won
numerous awards at major design shows
and has been featured in leading design publi-
cations. Bender has taught and guest
lectured in the San Francisco Bay Area for more
than twenty years.

PRIMO ANGELI
San Francisco, California
Collage

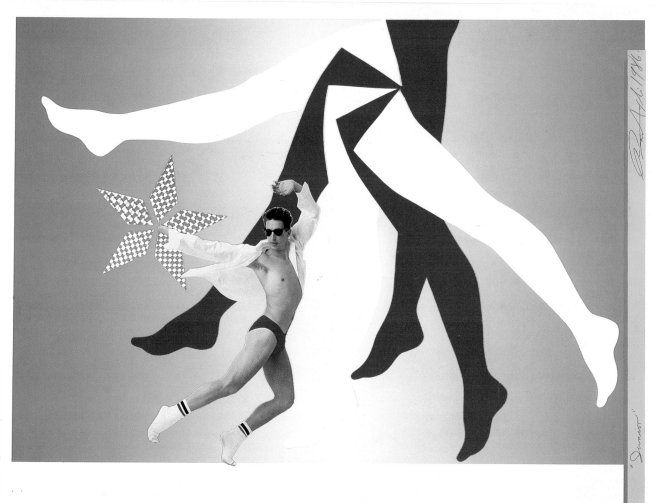

Photo of Ron Reagan Jr. courtesy of Annie Leibovitz.

Primo Angeli is
the principal of the San Francisco-based Primo Angeli
design firm. His creative direction in
packaging, corporate identity, and environmental
graphics has garnered him more than 250
awards. A number of his designs are in permanent
collections and exhibitions, including
those of the Metropolitan Museum of Art, the
Smithsonian Institution, the Warsaw
Poster Collection, the Cooper-Hewitt Museum, and the
Georges Pompidou Center.

2

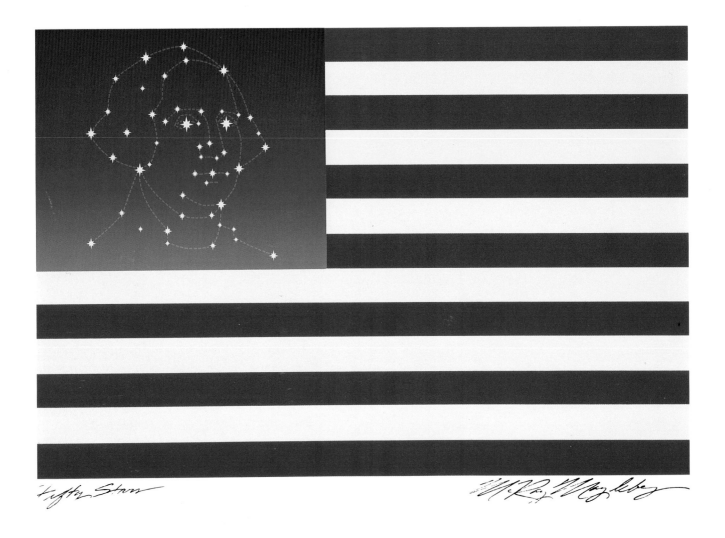

Fifty Stars McRay Magleby

McRay Magleby is
art director of the Brigham Young University graphics
department and professor of art at the
University of Utah, where he teaches graphic design
and illustration. His work has won
numerous awards and has appeared in major design
publications. In 1985, Magleby received the
University of Utah Distinguished Teaching Award; in
1986, he was voted Designer of the Decade by
the Council for Advancement and Support of Education.

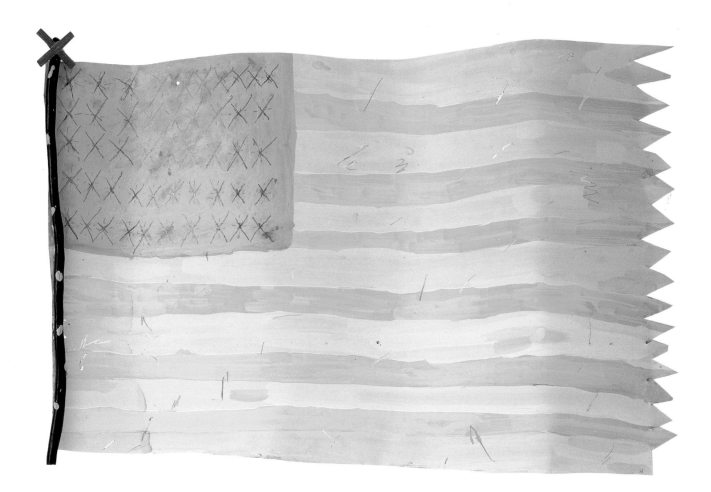

Born in the
Canadian province of Alberta, John Hersey
began his career as an illustrator in
Vancouver, British Columbia. In 1984, he began
experimenting with computer-generated
illustrations. Hersey, recipient of many national
illustration awards, currently lives and
works in San Francisco.

RANDALL JONES/
CHRISTINE CELANO-COONEY
Philadelphia, Pennsylvania
Airbrush on paper

84

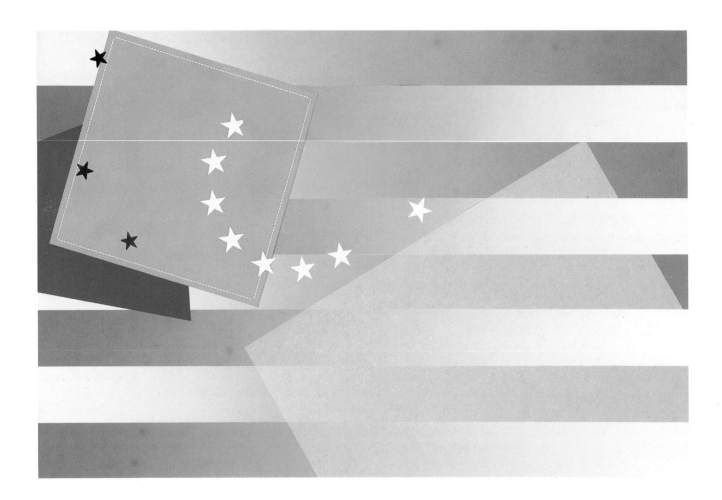

Randall Jones is
an associate of Katz Wheeler Design. A graduate of the
Philadelphia College of Art, Jones previously
worked for several advertising agencies and as a design
director for a New York mass transit system.
Formerly with Katz Wheeler, Christine Celano-Cooney
is an adjunct assistant professor at the Uni-
versity of Illinois. She previously taught graphic design
at the Philadelphia College of Art, her alma mater.

DAVID STEVENSON
San Francisco, California
Acrylic paint on paper

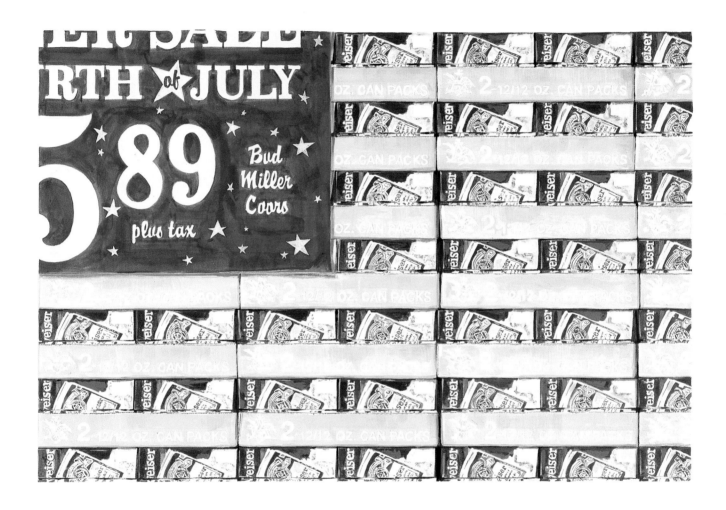

David Stevenson
grew up in Sonoma, California, and trained as a
graphic designer in Colorado. Three
years ago Stevenson shifted his career focus to
illustration and since has produced
artwork for corporate and advertising clients.
His illustrations have been repre-
sented in the major design annuals and in
touring exhibitions.

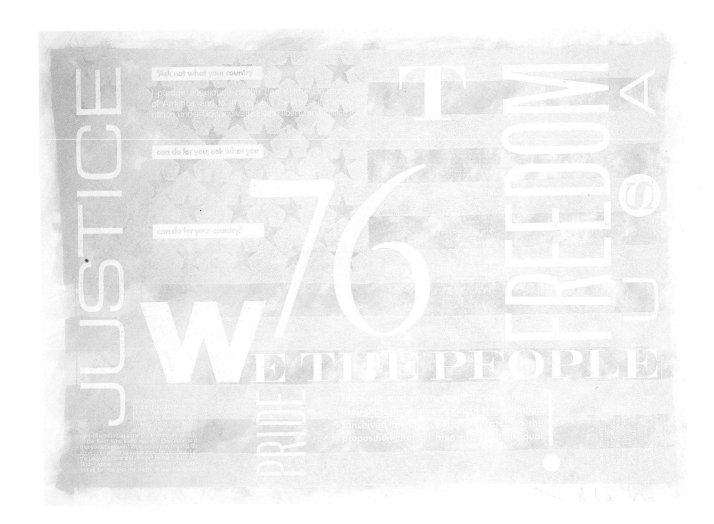

An award-winning
graphic designer whose work has been represented in
design annuals and magazines, Michael Mabry
serves a broad range of clients in the area of corporate
communications, packaging, and illustration.
Prior to founding Michael Mabry Design, Mabry was a
senior designer at Sidjakov, Berman & Gomez.
He lectures at the California College of Arts and Crafts
and is currently president of the San Francisco
chapter of the AIGA. Mabry's work is in
the permanent collection of the Library of Congress.

ROBBIE ADKINS
San Diego, California
Mixed media on watercolor paper

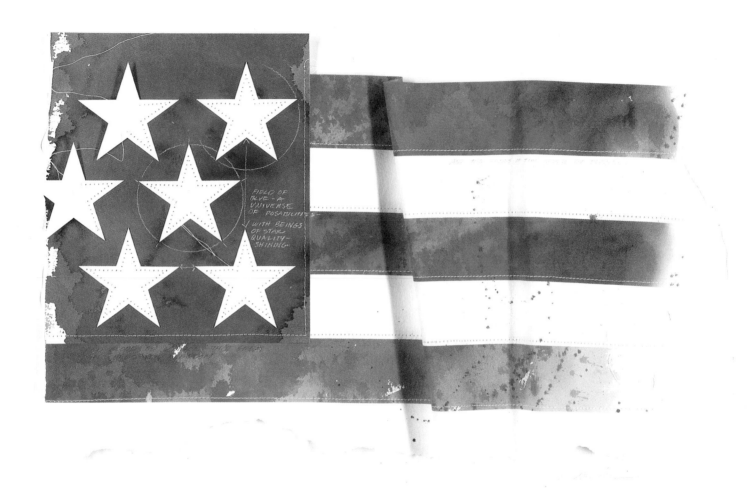

A native San Diegan,
Robbie Adkins studied design at San Diego State
University, graduating in 1969. After working
in a variety of design positions, ranging from magazine
art director to product designer, she established
Adkins Design in 1985. A recipient of numerous design
awards, Adkins also paints watercolors and
produces both handmade paper and serigraphs for the
interior design trade.

CHUCK BYRNE
San Francisco, California
Shadeditions paper

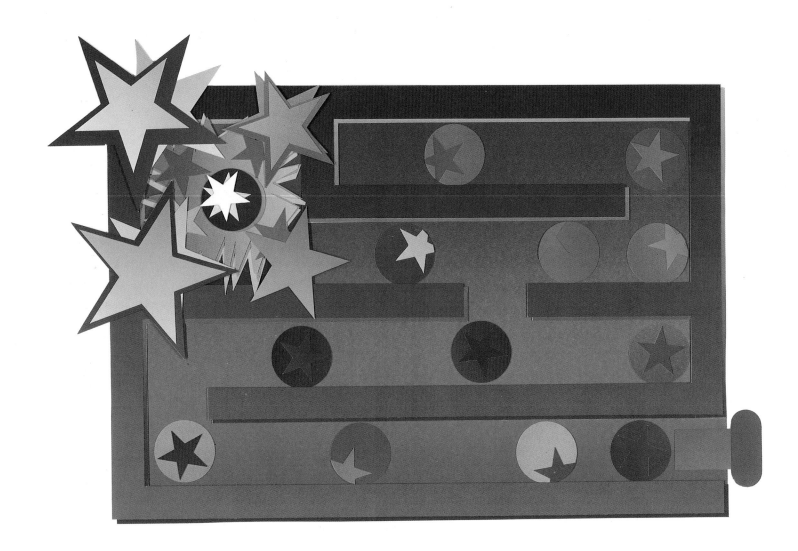

In 1978,
Chuck Byrne formed Colophon, a graphic design
firm located in Cincinnati. He is now
associated with Colophon in San Francisco.
Byrne is well-known for his poster
and book designs, which have been featured in
a number of design publications. He is
also a contributing editor to *Print* magazine.

EVERETT PECK

Lucadia, California
Gouache on board

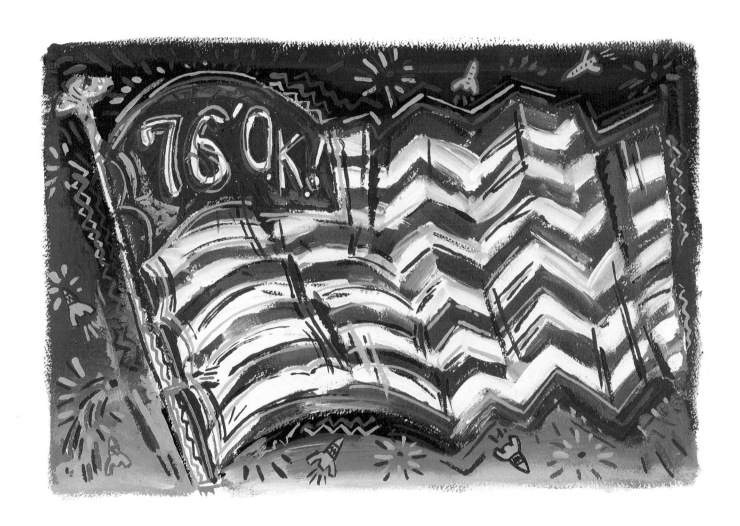

Everett Peck's
illustrations have appeared in publications as diverse
as the *New York Daily News* and *Playboy*
magazine, as well as on record albums for CBS. In
addition to his work for a variety of inter-
national clients, Peck has had his paintings exhibited
in Los Angeles, New York, and Tokyo. He
heads the illustration department at Otis Parsons
School of Design in Los Angeles.

NEIL SHAKERY
San Francisco, California
Identicolor on paper

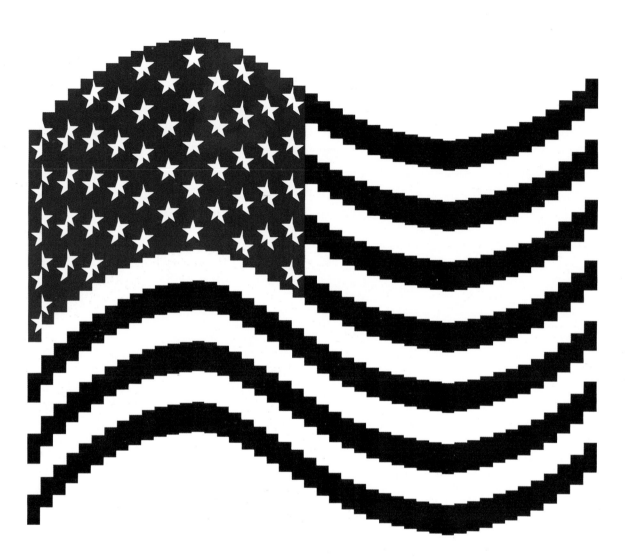

Born in
Canterbury, England, and educated at the Ontario
College of Art in Toronto, Neil Shakery
has been an editorial art director for *Look, Saturday
Review, Psychology Today,* and *The
Canadian Magazine,* and design consultant on several
other leading periodicals. Previously a
principal of Jonson Pedersen Hinrichs & Shakery, he
is now a partner of Pentagram. Shakery
is a member of the executive committee of the
Stanford Conference on Design and
a recipient of numerous coveted design honors.

CONRAD JORGENSEN
San Francisco, California
Photocopy collage on cut paper

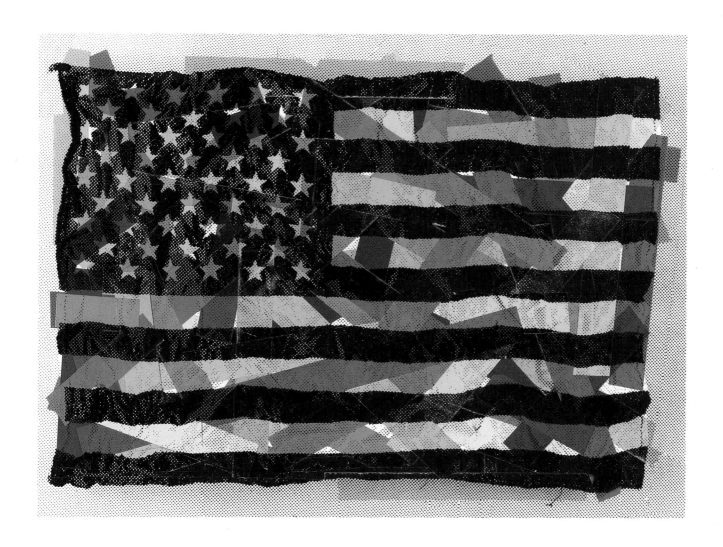

After graduating from
California State University, Chico, in 1977, Conrad Jorgensen
worked at Image Group and later moved to San
Francisco, joining S & O Consultants as a designer in
corporate identity and packaging. After a two-
year partnership with Craig Frazier, Jorgensen formed
Jorgensen Design in 1983, with partner
Karen Jorgensen. His work has appeared in numerous
exhibitions and publications
throughout the United States and abroad.

WARD SCHUMAKER

San Francisco, California

Colored pencil and gouache on paper

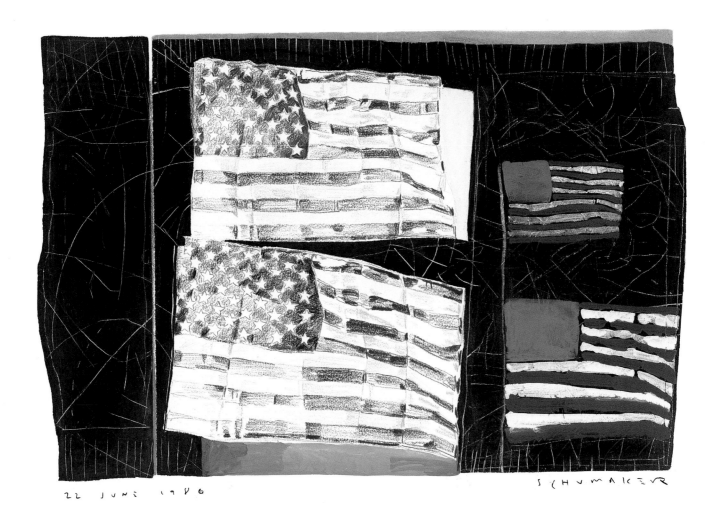

22 JUNI 1986

SCHUMAKER

A fine arts
graduate of the University of Nebraska, Omaha,
Ward Schumaker has created illustrations
for national periodicals and corporate clients
for the past decade. Schumaker, the
recipient of many illustration awards, has had
a number of one-man shows, and his
work has been featured in international
design magazines.

LENORE BARTZ
San Francisco, California
Pencil and pastel on paper

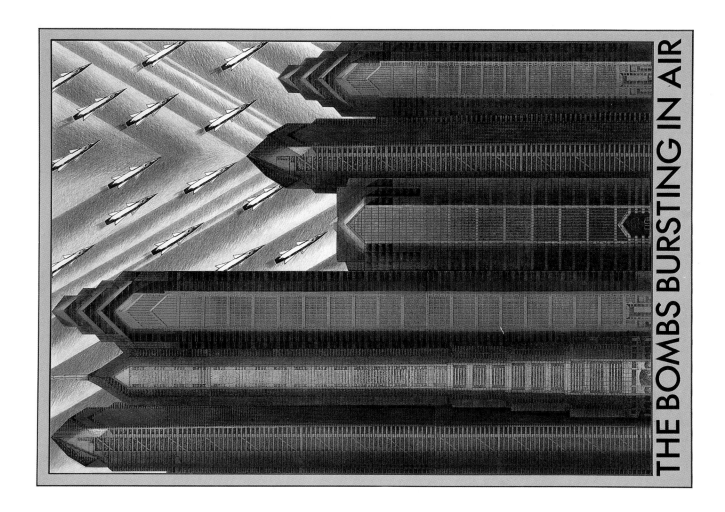

THE BOMBS BURSTING IN AIR

A graduate of the
University of Wisconsin, Lenore Bartz is a graphic
designer in the San Francisco office
of Pentagram. Her work has won numerous awards,
including two gold medals from the New York
Art Directors Club, and has been featured in major
design publications. She is currently
president of the Art Directors Club of San Francisco.

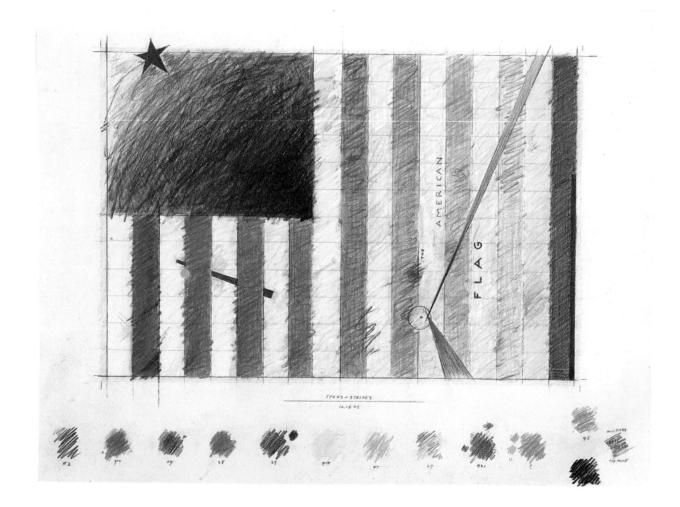

Thomas Ingalls
served as art director and design consultant for such
publications as *L.A. Free Press*, *Rolling Stone*,
Outside, and *Wet* magazine before forming Thomas
Ingalls + Associates in San Francisco.
Ingalls's firm specializes in design for newspapers,
magazines, and books. In addition
to receiving many design awards, Ingalls is
coauthor of *The Grill Book*.

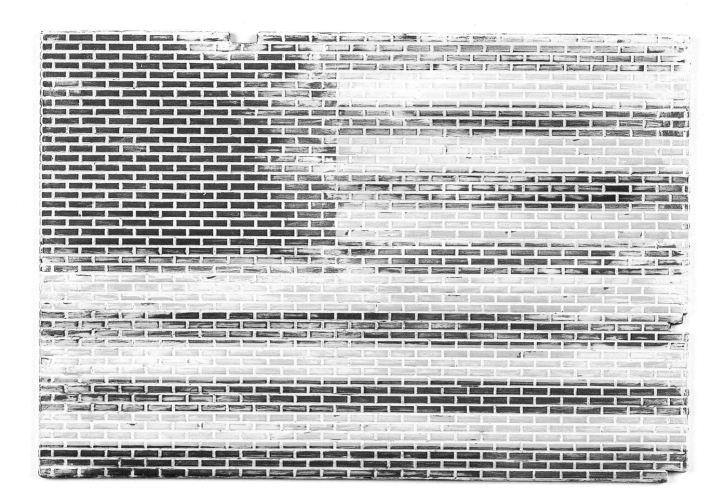

Tom Nikosey is
an award-winning artist specializing in typographic
design. His distinctive hand-lettering has
enhanced the album covers of many famous recording
artists, including Kenny Rogers, Eric Clapton,
and the Bee Gees. He also designed two Super Bowl
symbols and creates logos for film.
In addition to running Tom Nikosey Design in Los
Angeles, he teaches advanced lettering
courses at the Art Center College of Design.

HENRY STEINER
Hong Kong
Computer-generated Cibachrome

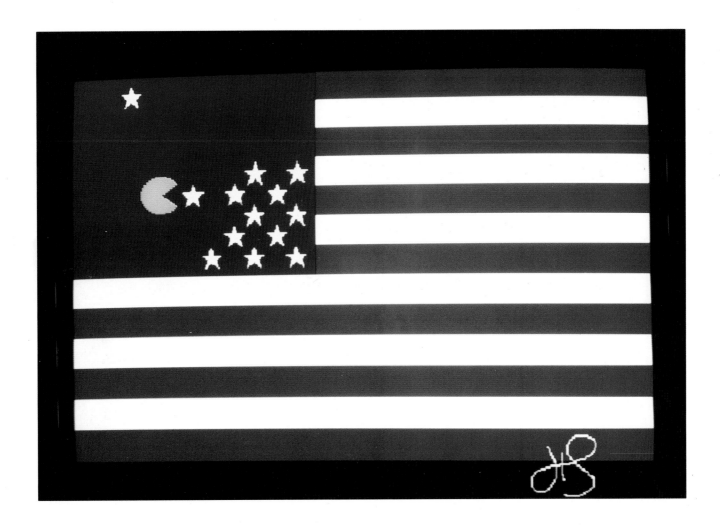

Born in Vienna
and raised in New York, Henry Steiner studied
fine art at Hunter College, graphics
under Paul Rand at Yale, and attended the
Sorbonne as a Fulbright fellow.
Steiner now heads Graphic Communication Ltd
in Hong Kong, producing a variety
of work from annual reports and architectural
graphics to postage stamp designs.

LAURIE GODDARD
Marblehead, Massachusetts
Assemblage on corkboard

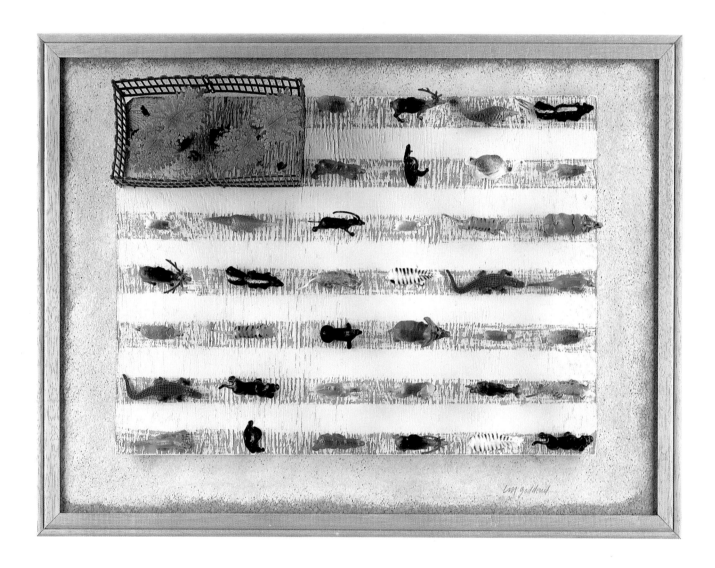

Formerly project
coordinator at Pentagram in San Francisco,
Laurie Goddard now creates
contemporary furniture art in Marblehead,
Massachusetts. Goddard graduated
from the Moore College of Art in Philadelphia
and worked for a graphic design firm
in Milan, Italy.

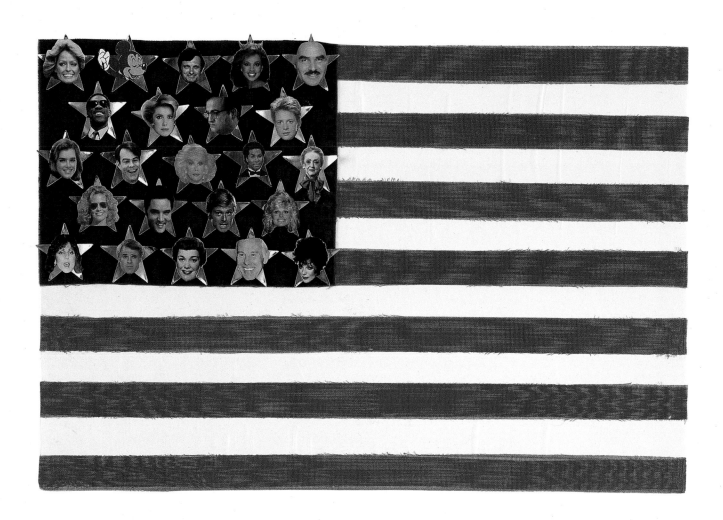

Samuel N. Antupit
is vice-president, director of art and design at Harry
N. Abrams. Previously, he was executive
art director of the Book-of-the-Month Club, principal
of Antupit & Others, and member of the
Push Pin Studio. Antupit specializes in book and
magazine design. His credits include
Esquire, *The New York Review of Books*, and *Art in
America*. He also operates Cycling Frog
Press and received an Emmy for art direction for
"Free to be You and Me."

DEBRA STINE
San Diego, California
Dyes on paper

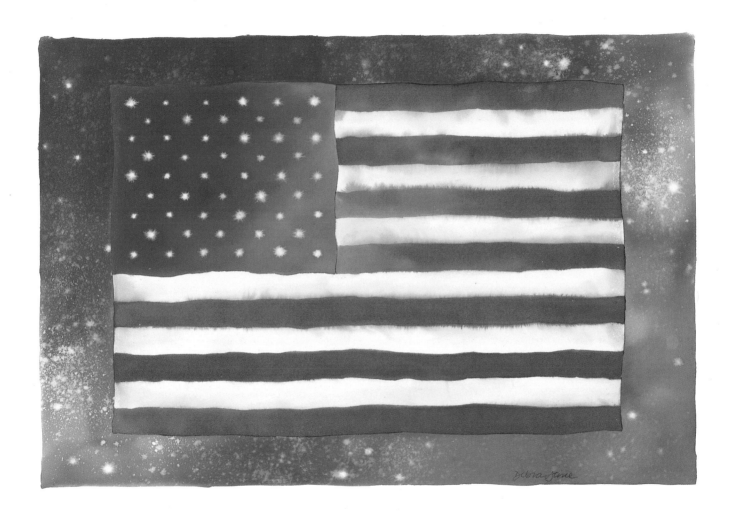

Free-lance illustrator
Debra Stine works for a number of national
advertising agencies, magazines,
book publishers, and corporate clients, in-
cluding Harcourt Brace Jovanovich
and *San Diego Home/Garden* magazine. Stine
received her bachelor of arts degree
from California State University, San Diego,
and attended the Art Center
College of Design.

Saul Bass has
received many awards and medals for his graphic
design. His film, *Why Man Creates*,
received an Oscar, plus a number of other major
awards at international film festivals.
Bass has been responsible for the development
of trademark and corporate identification
systems for leading businesses. Examples
of his work are in the permanent collections of
museums throughout the world.

LOWELL WILLIAMS/LANA RIGSBY
Houston, Texas
Watercolor on paper

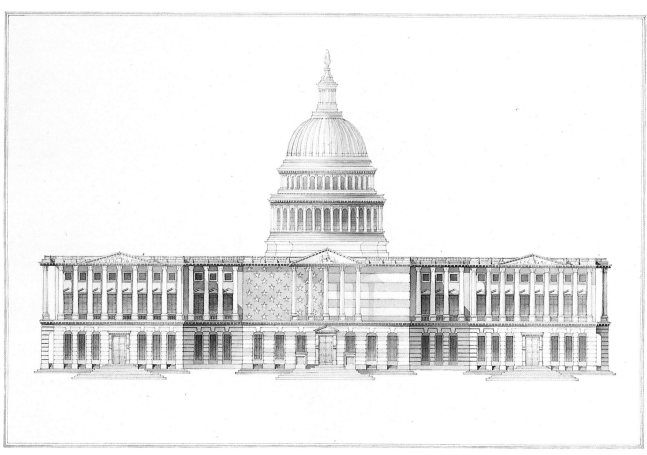

S T A R S & S T R I P E S
E A S T E L E V A T I O N
LOWELL WILLIAMS DESIGN

Lowell Williams
is president and design director of Lowell Williams
Design. Williams's work has been recognized
in numerous national and international design com-
petitions and profiled in professional
publications. Williams also serves on the board of
directors of the Houston Zoological Society.
Lana Rigsby is a graphic designer and illustrator with
Lowell Williams Design. At the present
time, she serves on the board of directors of the
Art Directors Club of Houston.

COLLEEN QUINN
San Francisco, California
Colored pencil on paper

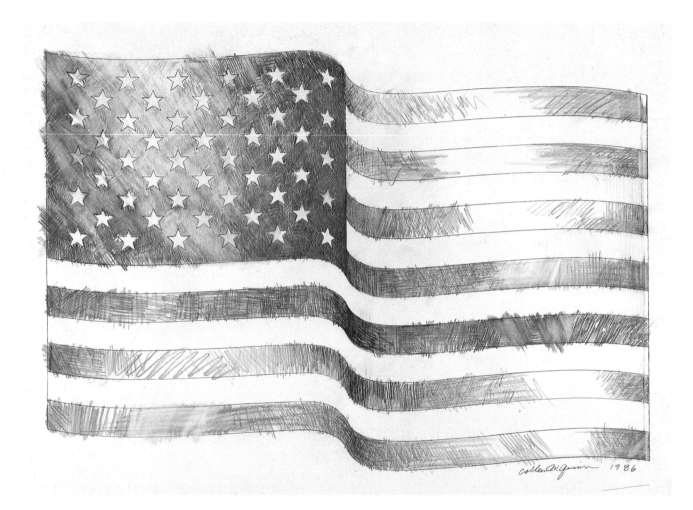

Colleen Quinn
produces illustrations for advertising, editorial,
and corporate clients. Her illustra-
tions have been featured in design annuals
published by *Graphis*, *Print*, and
Communication Arts. Among her awards are
medals from the Art Directors Club of
Los Angeles, the New York Art Directors Club,
the AIGA, and the San Francisco
Advertising Club's "Best in the West" show.

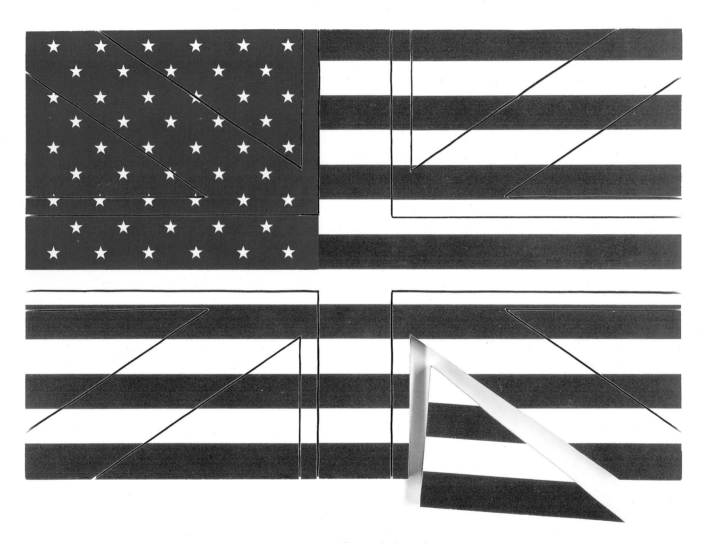

Born and educated
in London, Peter Harrison has lived and worked in
New York since 1957. Prior to becoming
a Pentagram partner in 1979, Harrison worked in
advertising, graphics, and environmental
design. His considerable experience in photography,
both behind the camera and as an art director,
has won him many awards. Harrison's work continues
to involve a wide range of design disciplines,
including architectural signage, packaging, corporate
identity, and exhibition design.

REX PETEET
Dallas, Texas
Theater gels on Plexiglas

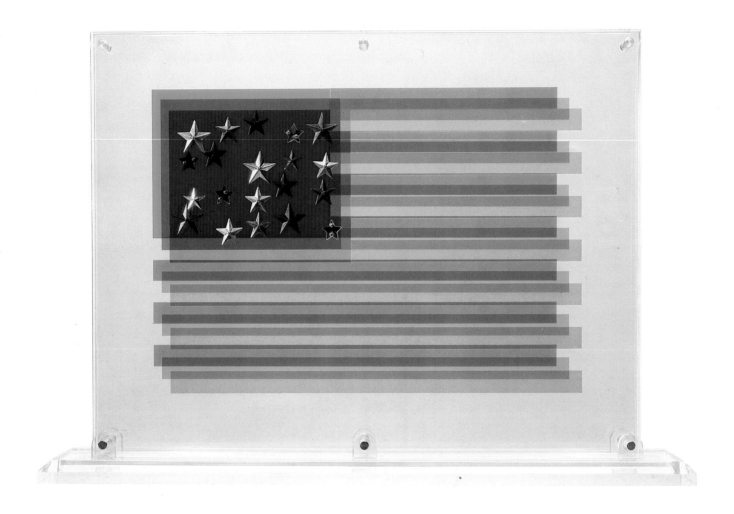

Rex Peteet worked
at several prestigious advertising and design firms
in Dallas before forming his own award-
winning company, Sibley/Peteet Design, with Don
Sibley. His work is frequently featured
in design magazines and is included in the permanent
collection of the Library of Congress.
Peteet lectures at design seminars around the country.

MASSIMO VIGNELLI
New York, New York
Newspaper collage

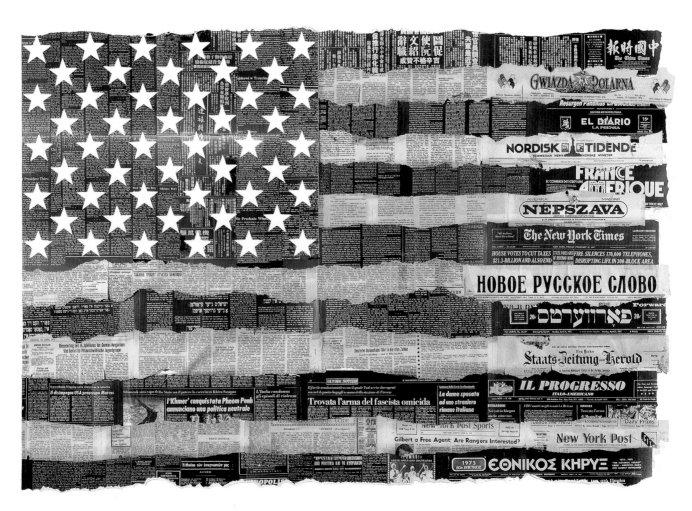

Born in Milan,
Massimo Vignelli studied architecture in Milan and
Venice. Since then, he and his wife, Lella,
an architect, have designed corporate and graphic
programs, transportation and architectural
graphics, exhibitions and interiors, and through
Vignelli Designs, furniture and other prod-
ucts. Massimo Vignelli is president of the Alliance
Graphique Internationale, a vice-president
of The Architectural League, and a past president and
1982 medalist of the AIGA. In 1985,
he received the first Presidential Award for
Design Excellence.

N

Tom Nikosey
Los Angeles, California
Page 95

O

Hank Osuna
San Francisco, California
Page 36

P

Everett Peck
Lucadia, California
Page 89

Alan Peckolick
New York, New York
Page 79

Daniel Pelavin
New York, New York
Page 54

Rex Peteet
Dallas, Texas
Page 104

Woody Pirtle
Dallas, Texas
Page 15

Christopher Pullman
Boston, Massachusetts
Page 59

Q

Colleen Quinn
San Francisco, California
Page 102

R

Susie Reed
San Francisco, California
Page 26

Gerald Reis
San Francisco, California
Page 69

Lana Rigsby
Houston, Texas
Page 101

Lissa Rovetch
San Francisco, California
Page 25, 65

Anthony Russell
New York, New York
Page 42

S

Paula Scher
New York, New York
Page 31

Ward Schumaker
San Francisco, California
Page 92

Michael Schwab
San Francisco, California
Page 57

Carl Seltzer
Newport Beach, California
Page 20

Neil Shakery
San Francisco, California
Page 90

Don Sibley
Dallas, Texas
Page 12

Steven Soshea
San Francisco, California
Page 70

Henry Steiner
Hong Kong
Page 96

Dugald Stermer
San Francisco, California
Page 33

David Stevenson
San Francisco, California
Page 85

Debra Stine
San Diego, California
Page 99

Ron Sullivan
Dallas, Texas
Page 49

Jack Summerford
Dallas, Texas
Page 16

T

Ken Thompson
Atlanta, Georgia
Page 55

Steve Tolleson
San Francisco, California
Page 44

U

Jack Unruh
Dallas, Texas
Page 47

V

Michael Vanderbyl
San Francisco, California
Page 32

John Van Dyke
Seattle, Washington
Page 37

Massimo Vignelli
New York, New York
Page 105

W

Sarah Waldron
San Francisco, California
Page 51

Alina Wheeler
Philadelphia, Pennsylvania
Page 53

Lowell Williams
Houston, Texas
Page 101

Design and Production

Design:
Kit Hinrichs
Pentagram

Editor:
Delphine Hirasuna

Photography:
Michele Clement, Barry
Robinson, Terry Heffernan
Flag kite photograph by
Ed Kashi

Historical Flags:
Flag quilt and flag gate
from the permanent
collection of the Museum
of American Folk Art,
New York

All other historic flags
from the collection of Kit
Hinrichs, San Francisco

Project Coordinator:
Amy Hoffman

Production Manager:
Tanya Stringham

Design Staff:
Susie Leversee

Typography:
Bodoni Book and
Bodoni Book Italic
Futura Extra Bold

Set by:
On Line Typography,
San Francisco

Printing:
Dai Nippon Printing
Tokyo, Japan

Exhibition

*Historical Exhibition
Coordinator:*
Linda Evans, Art Programs

*Contemporary Exhibition
Coordinators:*
Amy Hoffman, Pentagram
Sarah Keith, Michael
Mabry Design

Management and Staff of:
One Market Plaza,
San Francisco

Gensler & Associates,
San Francisco

Invitation Design:
Cathy Locke
Pentagram

Invitation Typography:
Reardon & Krebs

Invitation Printing:
Foreman Leibrock

Exhibition Panels:
Thomas Swan Signs

Exhibition Design:
Tom Horton

Exhibition Installation:
Andy Brubaker
Margie Chu
Noreen Fukumori
Sarah Healy
May Liang
Doug Murakami
Valerie Turpen

Special Thanks

Auctioneer:
Harry Murphy

Carolyn Hightower,
AIGA director

Bruce Blackburn,
AIGA president

AIGA San Francisco
Chapter Officers:
Michael Mabry, president
John Haag, vice-president
John Bricker, secretary
Craig Frazier, treasurer

The American Institute of Graphic Arts
(AIGA), based in New York City,
was founded in 1914. A national organization
with chapters in twelve cities, it
is the oldest and largest professional group
in the United States devoted to the
advancement of graphic design. The AIGA
conducts an interrelated program
of competitions, exhibitions, publications,
and seminars for its five thousand
members, as well as educational activities
and projects in the public interest.